SUPERHERO EXPLOSION
60 Easy Lessons for Drawing Comics!

Neal Yamamoto

IMPACT
CINCINNATI, OHIO
www.impact-books.com

About the Author

Neal Yamamoto is a funny guy. A freelance illustrator, Neal sprang from the primordial soup eons ago hoping to be a writer. Today his minor writings are largely forgotten, but magazines such as *L.A. Parent*, *Backstage West* and *The American Legion Magazine* have used his recent feverish scribblings. His art has also invaded the pages of dozens of activity books (you can find them by doing an Internet search under his name), tons of T-shirts and at least a few anthology comics. Presently, Neal is composed of several elements not found on the periodic table, repeats the palindrome "Madam, I'm Adam" to far too many people, and is hard at work on his self-published graphic novel *7-SEI*, due to be released in late 2005.

YA WANT *ART* ??

Other fine IMPACT Books are available from your local bookstore, art supply store or direct from the publisher.

10 09 08 07 06 5 4 3 2 1

DISTRIBUTED IN CANADA BY FRASER DIRECT
100 Armstrong Avenue
Georgetown, ON, Canada L7G 5S4
Tel: (905) 877-4411

DISTRIBUTED IN THE U.K. AND EUROPE BY DAVID & CHARLES
Brunel House, Newton Abbot, Devon, TQ12 4PU, England
Tel: (+44) 1626 323200, Fax: (+44) 1626 323319
Email: mail@davidandcharles.co.uk

DISTRIBUTED IN AUSTRALIA BY CAPRICORN LINK
P.O. Box 704, S. Windsor NSW, 2756 Australia
Tel: (02) 4577-3555

Library of Congress Cataloging in Publication Data
Yamamoto, Neal.
Superhero explosion 60 easy lessons for drawing comics / Neal Yamamoto.— 1st ed.
 p. cm
Includes index.
ISBN 1-58180-652-3 (pbk. : alk. paper)
1. Heroes in art--Juvenile literature. 2. Cartoon characters--Juvenile literature. 3. Drawing--Technique--Juvenile literature. I. Title: Superhero explosion sixty easy lessons for drawing comics. II. Title.
NC1764.8.H47Y36 2005
741.5--dc22 2005013167

Edited by Mona Michael
Designed by Wendy Dunning
Production art by Donna Cozatchy
Production coordinated by Mark Griffin

Acknowledgments

Big thanks to Pam Wissman for getting me this gig, Wendy Dunning for making it all look good, and Mona Michael for putting up with my extensions and turning my ramblings into something readable. Thanks also to my family and friends who put up with my complaining about all the work I have to do.

METRIC CONVERSION CHART

To convert	to	multiply by
Inches	Centimeters	2.54
Centimeters	Inches	0.4
Feet	Centimeters	30.5
Centimeters	Feet	0.03
Yards	Meters	0.9
Meters	Yards	1.1
Sq. Inches	Sq. Centimeters	6.45
Sq. Centimeters	Sq. Inches	0.16
Sq. Feet	Sq. Meters	0.09
Sq. Meters	Sq. Feet	10.8
Sq. Yards	Sq. Meters	0.8
Sq. Meters	Sq. Yards	1.2

TABLE OF CONTENTS

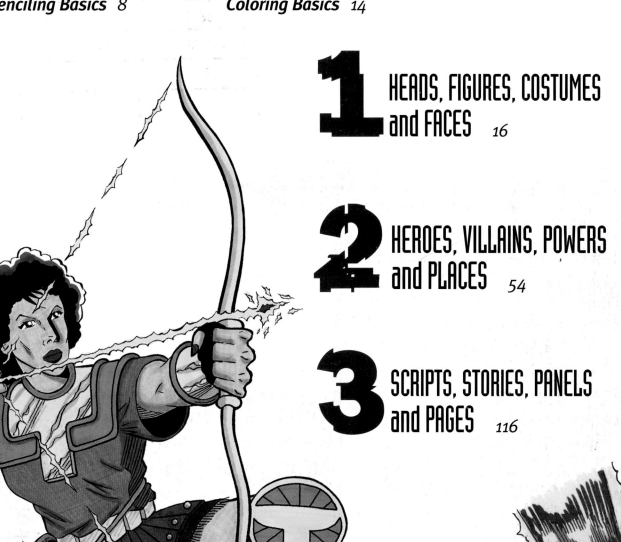

HOW A COMIC GETS DONE

Flying and super strength are pretty cool abilities, but the ability to produce a monthly, full-color, 22-page comic book is even more amazing. So how do the pros do it without super speed or time travel powers? Traditionally, it takes a team of creative people working tirelessly (okay, they actually get pretty tired) under a tight deadline. Occasionally, individuals do more than one job, like an artist might do both penciling and inking, but here's how it usually works.

1 *Plotting and Scripting*
A super-creative editor or writer comes up with a basic idea. That person writes a plot outline and sometimes a full script with dialogue and panel directions.

2 *Penciling*
The penciler breaks the story down into visuals to establish the pace, accentuate the drama and create movement. All this must happen as fast as possible, at least two to three pages a day to meet a monthly deadline.

3 *Inking*
The inker transforms the pencils into black line art suitable for printing. He also adds texture, depth and clarity and occasionally fixes mistakes the penciler missed. Once the ink is dry, the inker erases all the original pencil lines.

4 *Lettering*
Before computers, hand lettering was done directly onto penciled pages before inking. Today, most lettering is done with a computer after inking. Regardless of the method, lettering should be clean, accurate and easy to read and the spelling must be mistake-free.

5 *Coloring*
Coloring consists of two jobs: first, establishing the look and mood of the art through color, and second, creating a color guide on the computer for the printer to follow (the latter process is called *color separating*).

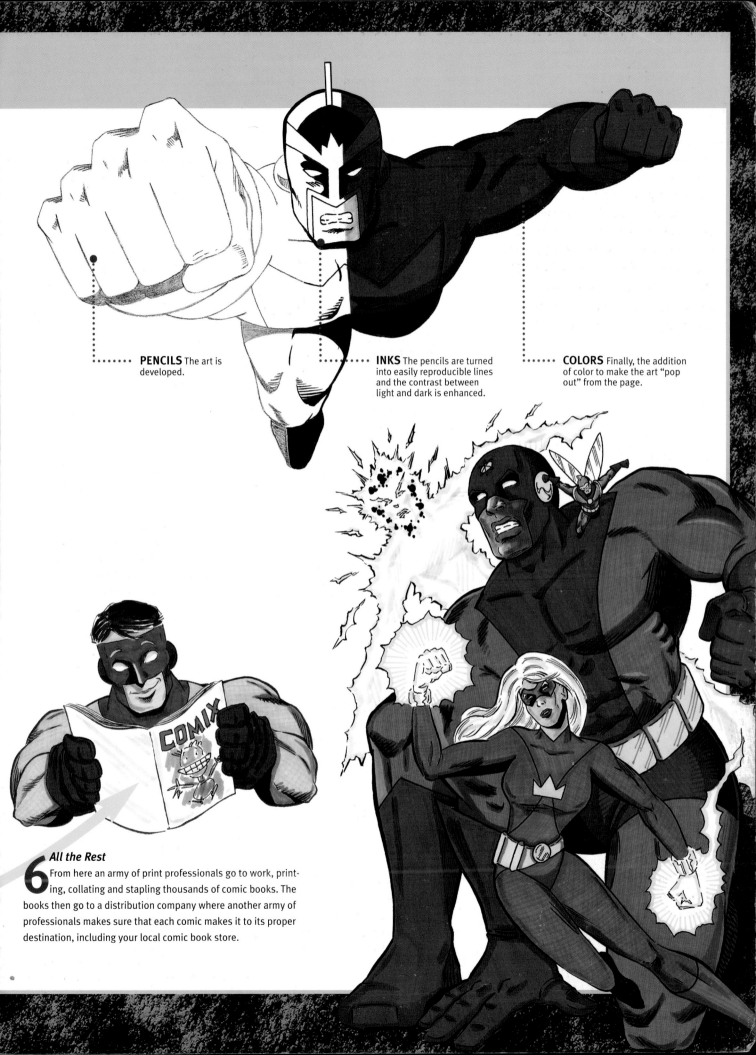

PENCILS The art is developed.

INKS The pencils are turned into easily reproducible lines and the contrast between light and dark is enhanced.

COLORS Finally, the addition of color to make the art "pop out" from the page.

6 *All the Rest*
From here an army of print professionals go to work, printing, collating and stapling thousands of comic books. The books then go to a distribution company where another army of professionals makes sure that each comic makes it to its proper destination, including your local comic book store.

COMIX

HOW TO GET READY

If you're reading this, you want to learn to draw superheroes. To get started with that right away, all you need is your imagination. Well, maybe you need one or two other bare necessities. The following is a short list of items most professional artists keep in their capes and utility belts (I'll assume you already have a sturdy table and a good desk lamp). On occasion I mention a certain manufacturer or product, but that's just my personal preference, not a rule written in stone. Experiment with different brands, instruments and techniques to find out what works best for you.

PAPER OR BOARD

For rough layouts or simple sketches, any kind of paper is fine—the cheaper, the better. Papers come in a variety of *weights,* or paper thicknesses (expressed in pounds). Final art always looks better on heavier paper. I used 8½" × 11" (22cm × 28cm) heavyweight (32-lb. or 65gsm) laser paper for most of the illustrations you'll see here. Some people, myself included, prefer a *plate* (also called *hot press*) finish, which has a very smooth surface and is good for inking. Most professional comic book artists use a 2- or 3-ply bristol board sheet, cut to 11" × 17" (28cm × 43cm) with a 10" × 15" (25cm × 38cm) image area. Bristol board has a thicker, cardstock quality weight that stands up to heavy-duty inking.

PENCILS

That yellow no. 2 pencil is great for your math homework, but an art pencil is a better tool to focus your mutant artistic abilities. Art pencils come in hard (H) and soft (B) grades of lead, with two medium (HB and F) grades in between. Most artists use an HB or F lead. A pencil lead that's too hard will produce a very light line and can scratch or indent your drawing surface. A lead that's too soft creates an extremely dark line that's easily smudged and difficult to erase.

PENCIL SHARPENERS

Any kind will do in a pinch, but an electric sharpener with an auto-stop feature will prevent the over-sharpening that causes lead breakage.

ERASERS

An eraser is the artist's best friend and you should have more than one kind. First, a *kneaded rubber eraser*, which is pliable and non-abrasive; second, a *gum eraser*, which is grease-free and crumbles as it's used to prevent scratching your art surface; and lastly, a harder all-purpose rubber eraser, like a Pink Pearl.

Your Pencil Is One of Your Most Important Tools
To take full advantage of your artistic talent, look for some quality artists' pencils. They're inexpensive and can make a big difference in your drawings.

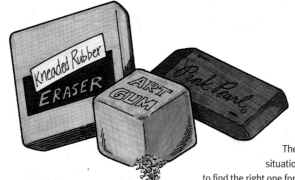

Keep a Variety of Erasers With Your Drawing Tools
The same eraser doesn't suit all situations. Shop around for erasers to find the right one for each situation.

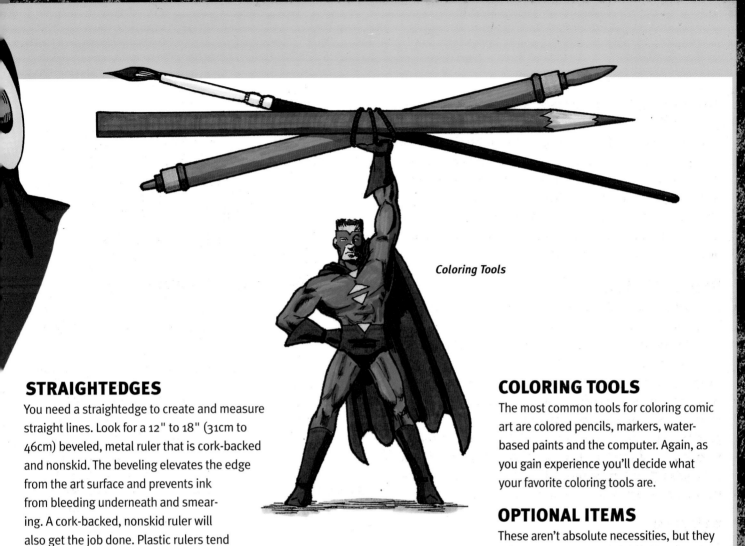

Coloring Tools

STRAIGHTEDGES

You need a straightedge to create and measure straight lines. Look for a 12" to 18" (31cm to 46cm) beveled, metal ruler that is cork-backed and nonskid. The beveling elevates the edge from the art surface and prevents ink from bleeding underneath and smearing. A cork-backed, nonskid ruler will also get the job done. Plastic rulers tend to warp, so a metal ruler is always better.

DUST BRUSH

Use a soft-haired brush to dust the excess graphite and eraser crumbs from your drawings. Never use your hands to wipe off your art. The oil from your skin will smudge your pencils and leave slick spots on the surface of your drawing.

INKING TOOLS

Markers, technical pens, dip pens, nibs and brushes—your choices are endless. They all work well with different advantages and disadvantages. What you use will depend on your style and preference. See page 12 for more tools.

COLORING TOOLS

The most common tools for coloring comic art are colored pencils, markers, water-based paints and the computer. Again, as you gain experience you'll decide what your favorite coloring tools are.

OPTIONAL ITEMS

These aren't absolute necessities, but they can make your life as an artist a little easier. French curves, circle and ellipse templates, and a compass with a technical pen attachment are helpful for creating accurate curves and circular shapes in your drawings. Also, keep scrap paper on hand to use as a slip sheet to protect your drawing surface.

Dust Brush

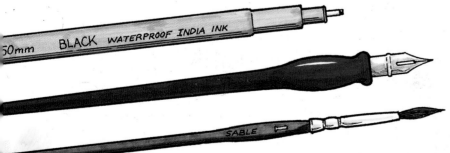

Inking Tools

7

PENCILING BASICS

For pencil drawings, use a medium grade lead, such as F or HB, because it's dark enough to see but light enough for easy erasure with a minimum of smudging. Hold the pencil firmly, but comfortably, at least two inches (5cm) away from the tip.

Keep your beginning lines light so you'll be able to erase any mistakes easily. Start by lightly sketching in where everything is supposed to go, using your kneaded rubber eraser for any corrections. Don't grip the pencil too tightly or you'll give yourself a hand cramp. And don't hold the pencil too close to the tip; this will also cause your hand to cramp up.

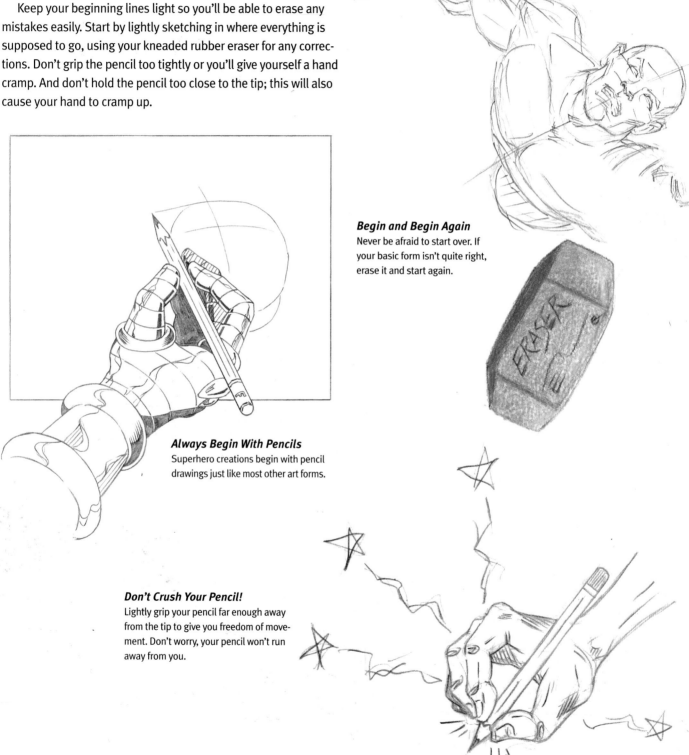

Begin and Begin Again
Never be afraid to start over. If your basic form isn't quite right, erase it and start again.

Always Begin With Pencils
Superhero creations begin with pencil drawings just like most other art forms.

Don't Crush Your Pencil!
Lightly grip your pencil far enough away from the tip to give you freedom of movement. Don't worry, your pencil won't run away from you.

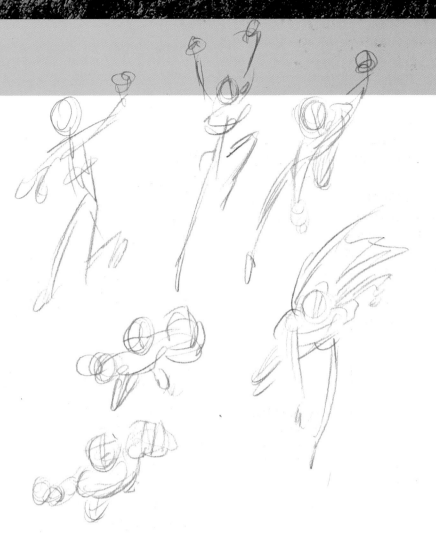

Start With Thumbnail Sketches

Always begin by roughing out your ideas in *thumbnail* form. Thumbnails are small, very rough sketches that help create a clear mental image of what you want to draw and to work out any major flaws. Don't spend too much time on the thumbnails. They're only meant to help you work out very basic issues of form and composition. Thumbnailing will also help you warm up your hand and brain, making it easier to access your formidable mutant creative powers.

Clean-Up Tip

If your drawing becomes too dark or too jumbled up with unnecessary sketch lines, squeeze your kneaded eraser into a rolling pin shape and roll it across your drawing a few times. This will lighten the pencil lines without completely erasing them.

PROTECT YOUR DRAWING

Before starting work on your final art, place a sheet of paper between your palm and your drawing surface. This will prevent smudging and keep the natural oils in your hand from getting onto your work surface. An oily palm print can ruin your art. Some professional artists go as far as to wear a cotton glove while drawing.

BASIC DRAWING TECHNIQUES

There are two types of black-and-white pencil drawings—*tone drawings* and *line drawings*. A tone drawing uses various shades of gray while a line drawing uses only line and flat black. For clarity, speed, and ease of reproduction, most comic books are penciled and inked in line, with the color added in later. A line drawing's sides are done with *hatched* and *cross-hatched* lines, with the shadow done as a flat black.

If you're going to ink your work (as most comic artists do), it'll be easier if you imagine your pencil line as a flat black, instead of a dark gray. It's almost like drawing with a black marker: no shades of gray, just black and white (except you can still erase.)

LIGHT AND SHADOW

No, Light and Shadow are not the names of a new crimefighting duo (at least not yet). Light and shadow refer to your source of light and the darkness that's created by that light. The contrast between light and shadow on an object as it gradates from brightest light to deepest shadow is what gives a drawing its feeling of volume. Since the eye registers darker values as receding and lighter values as advancing, shading creates the sense of depth that makes things look three-dimensional.

Where you place the light source determines a variety of looks and moods. Old horror movies made the monster appear more menacing by lighting him from the bottom. Normally your source of light decides where your blacks will be. But because shadows add a sense of depth, drama and visual interest, many artists now alter its placement regardless of where the actual source of light is.

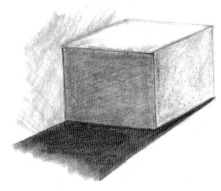

Tone Drawing
Blended pencil strokes create the various shades of gray and black that make up this cube.

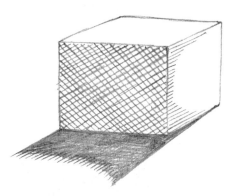

Hatched Drawing
Here you create the shades of gray and black with hatched and crosshatched lines instead of solid tones. You can apply the lines with pencil or inks.

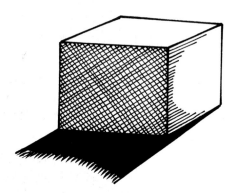

Inked Drawing
When you apply hatched lines with ink, you eliminate the grays and turn your drawing into straight black and white.

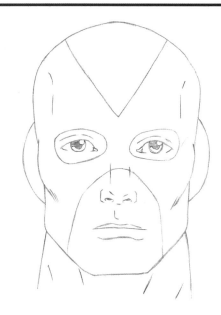

Basic Line Drawing
Without flat blacks and shadowing there is little dramatic impact to a drawing.

TRY THIS!

To see how light affects shadows in real life, get a flashlight and look in the mirror as you shine the beam on your face from different angles. You'll see the shadows better if you do this in a darkened room.

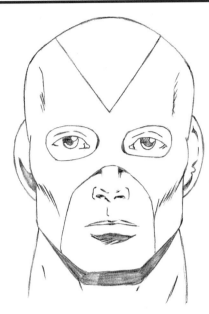

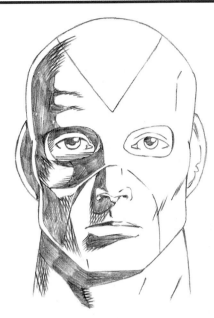

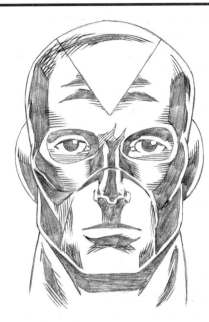

Flat Light
Here the character is softly lit from all sides, as he might be outside on a sunny day. Basic blacks exist only in the main shadowy places such as the areas underneath the lower lip and the chin.

Single Light
When a strong light shines from a single direction it creates heavy shadows on the opposite side.

Altered Shading
In this case you add shadows regardless of the light source. Many artists draw Batman and Captain America this way, adding a dark patch to their foreheads for drama and contrast. Use this type of shading sparingly though, as overuse will lessen its impact.

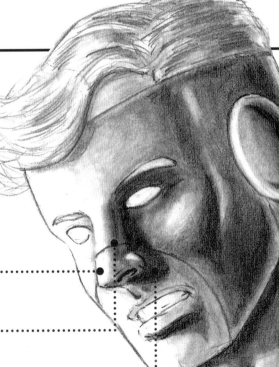

REFLECTED LIGHT
Will show up near the outer edge opposite the light source.

LIGHT SOURCE Where the light is coming from.

HIGHLIGHT (sometimes called the hot spot) The bright areas of light on the object's surface.

SHADOW The dark side of a solid or opaque object directly opposite the light source. Here the nose is the opaque object and the shadow is on the side directly opposite the light source.

CAST SHADOW The shadow cast by an opaque object blocking the light source. Again, the nose is the opaque object and casts a shadow.

INKING BASICS

Photocopy your original pencil art onto heavy duty paper to practice inking while you're learning. When you decide to begin inking your original pencil drawings, use a slip sheet to keep the oils from your hand away from the art (see page 9). When the ink has dried, erase the pencil lines with your kneaded rubber eraser. For the more stubborn pencil marks, use the art gum eraser. Only use pink rubber erasers to clean smudges or lines from the areas surrounding the actual art.

As with any art technique, there is no single, definitive way to ink. All that matters is whether or not it works. If you're using a tree branch and it gives you good results, go with it. The majority of artists use one or more of four types of tools for inking: markers, technical pens, dip pens and nibs, and brushes.

FELT-TIP MARKERS

It's good to start with markers because the technique feels most like pencil drawing. Just remember that you can't erase mistakes. Get a variety of thick and thin tipped markers that contain waterproof (water*proof*, not just water-resistant) India-density black ink, especially if you're going to add color. Anything less and your ink will either run when you add watercolor over it or fade after a few days. Before starting, test your markers on some scrap paper to see how much the ink bleeds.

TECHNICAL PENS

Technical pens (sometimes referred to as drafting pens) were originally used by designers and architectural artists. These pens come in a variety of line widths and with proper care, should last a lifetime. Proper care involves using India-density ink made specifically for technical pens. Any other kind of India ink will clog your pen and eventually render it useless.

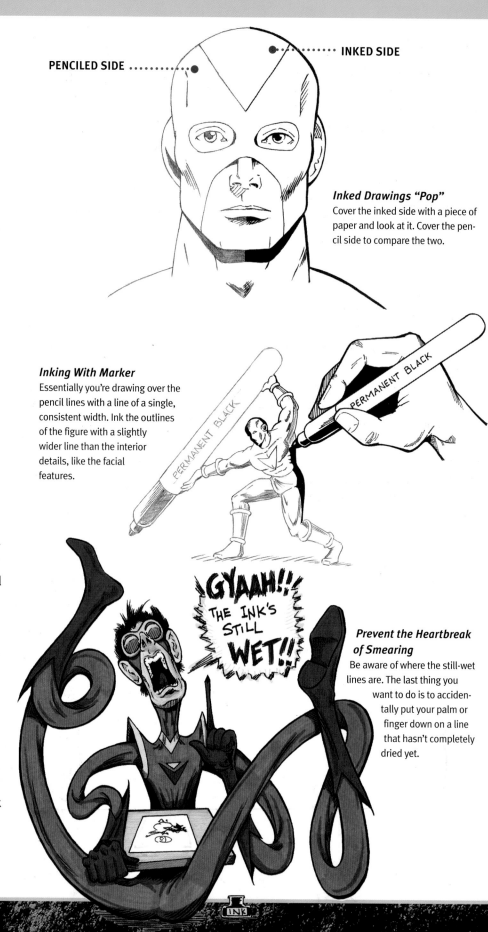

PENCILED SIDE ············ INKED SIDE

Inked Drawings "Pop"
Cover the inked side with a piece of paper and look at it. Cover the pencil side to compare the two.

Inking With Marker
Essentially you're drawing over the pencil lines with a line of a single, consistent width. Ink the outlines of the figure with a slightly wider line than the interior details, like the facial features.

GYAAH!! THE INK'S STILL WET!!

Prevent the Heartbreak of Smearing
Be aware of where the still-wet lines are. The last thing you want to do is to accidentally put your palm or finger down on a line that hasn't completely dried yet.

DIP PENS AND NIBS

Dip pens usually consist of a separate pen-holder and a metal *nib* or tip. The nibs come in a variety of shapes and sizes. Most manufacturers separate their nibs into drawing nibs or lettering and calligraphy nibs. Calligraphy nibs are usually chisel-shaped. The width of the ink line from these pens varies depending on the amount of pressure you use. This lets you create more expressive lines than you can with markers or technical pens.

BRUSHES

Most artists use sable brushes in sizes between numbers 0 and 3. The Winsor & Newton Series 7 is a favorite with many inkers, although they are rather expensive. The main advantage to brush inking is the ability to greatly vary the line width within a single stroke. The biggest disadvantage is the difficulty in learning to use the brush. Brush technique depends on being able to control the amount of pressure you exert on the brush. Learning to control that pressure takes a lot of practice.

How to Ink With Technical Pens

The basic idea of inking with technical pens is the same as using markers. Hold the pen a little more upright than usual though, so that the tip makes full contact with the paper.

How to Ink With Dip Pens

Dip your pen into a bottle of water-proof India-density black ink. Don't immerse the nib, just coat the top half. Wipe the excess ink against the rim of the ink bottle and draw a test line on a piece of scrap paper. If there's too much ink on the nib, the ink will blob and bleed. Continue to wipe ink on the bottle's rim until you get a clean ink line. Always pull the pen backwards at an angle.

Never Push a Dip Pen Forward

The nib on a dip pen is a sharply pointed piece of metal that will splatter and dig into the paper if it's thrust forward. After each use, immediately wash the ink off the nib so it doesn't dry and erode the point.

Use Brushes for the Most Line Control

After dipping your brush, wipe off the excess ink on the bottle's rim, then, on a scrap piece of paper, lightly roll the bristles into a fine point. Now you're ready to go. With a brush you can change from a very thin line to a very thick one with a single stroke.

WHY INK?

During the Golden Age of comics (1930s–1940s), printers found it hard to accurately reproduce pencil drawings, so most comic book art had to be finished in ink. Today's printing is much more precise, but an inked line is still easier to reproduce. It adds permanence to the art (smudging is a major problem with pencil drawings), makes it clearer to the human eye, and is easier to color.

COLORING BASICS

So you've finished your inked art and you want to add color. Here's a familiar tip: make a few photocopies of the art to practice on first. If you're using markers, copy your pencil drawing onto heavyweight, semi-gloss laser paper. For water-colors and colored pencil, use card stock. It has a surface grain that works better for pencils and watercolor paints.

While rules that work for markers may not work as well for colored pencils or inks, two rules apply in almost all cases:

1 Adding black or gray to darken a color will also deaden the intensity of that color. Use a darker version of the color instead.

2 When adding highlights, use an *opaque* (not see-through) watercolor or an acrylic based white paint. White corrective fluid isn't made for artwork and will cause your ink and colors to bleed, crack and peel.

Color can help almost any drawing come to life.

COLORED PENCILS

Easiest to begin with, colored pencils come in hundreds of hues and shades, so it's better to get a twenty-four or thirty-six pencil pack that will give you a basic range of colors instead of buying them individually. There's also a colorless blender pencil, which you will have to buy separately, that's used to blend colors together. Some artists use the white pencil as a blender, though it slightly lightens the overall color.

How to Handle Your Colored Pencils
Use a hand sharpener for colored pencils. Electric sharpeners tend to shave off too much of the lead making it brittle. To get a really sharp point, rub the tip against a piece of scrap paper. Add color slowly, using a light touch. The more pressure you use, the more opaque the color and in the beginning you want to keep the color soft. Start with the lightest areas first, building up the color, then move on to the darker shades.

COMPUTER COLOR

Most computer coloring consists of scanning in the inked work and adding color using software like Adobe Photoshop or Paint Shop Pro. If you already have the necessary hardware and software, there are many Internet groups with free tutorials to help you sharpen your technical coloring skills.

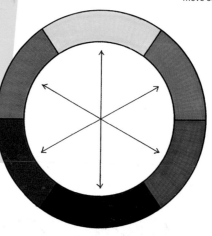

Complements Give Serious Contrast
Complementary colors are colors that are opposite each other on a color wheel. Use them when you want some serious punch to your characters. You can buy a color wheel at any art supply store.

MARKERS

Markers come in three types: alcohol-based, water-based and oil-based. Never use the oil-based markers. The oil will dissolve and smear your black line. Alcohol- and water-based markers work fine. Most are double ended, with a fine tip on one side and either a brush or broad tip at the other. Some are refillable and can even be hooked up to an airbrush or air canister system.

Markers work best on extremely smooth surfaces. Rough papers absorb too much ink and may cause bleeding along the edge of a line. Art stores sell specialty marker tablets, but smooth heavyweight laser paper will also work.

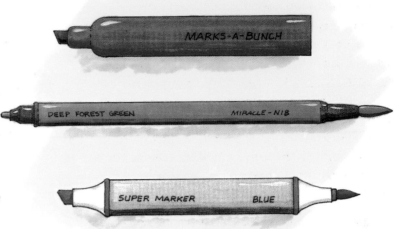

WATERCOLORS, INKS AND DYES

Although watercolors, inks and dyes are each made differently, they're all transparent and give similar effects. You can get watercolor paint in both tube and cake form. Colored inks and dyes exist only as liquids.

When painting, start with the lightest colors first, then move on to the darker ones. Like with markers, if you overlap colors, the layers underneath will show through. These won't come out as bright as markers, but there's less streaking and blending is much easier.

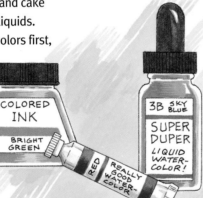

What You Should Know About Markers

There's no need to buy the most expensive brand of markers you can find. I colored many of the characters in these pages with one of the less costly brands. Just keep in mind that some markers are wetter than others and have better coverage, although they take longer to dry. Try them before you buy them if you can.

Apply color in even, parallel strokes to avoid blotchy areas. Remember, these are transparent colors, so if you overlap colors, the layers underneath will still show through.

Take Care of Your Paints, Inks and Dyes

To prevent drying, store your colored inks and dyes in a cool, shaded environment. Tube watercolors can also dry out and, given the cost of a single tube, should also be stored in a cool place. Speaking of cost, getting a large palette of tube watercolors (even the cheaper brands) can break the bank. Pan color sets are more economical, less vulnerable to heat and easily portable.

LAST WORD ON SUPPLIES

Your art supplies don't need to be expensive. I drew, inked and colored most of the characters you'll see on heavyweight laser paper available at any office supply store. I chose most of the remaining supplies (pencils, waterproof ink and water-based markers) according to whatever brand was cheapest. I spent a little more on the occasional technical pen and inking brush, but, these tools should last a long time.

1

HEADS, FIGURES, COSTUMES AND FACES

You've just dreamed up the world's greatest superhero—someone more powerful than Superman, cooler than Wolverine and better looking than Bruce Wayne. Now all you have to do is draw him. No problem.

Your hero may be faster than lightning and stronger than steel, but the techniques used to draw him are the same ones used to draw plain people like you and me. The first half of this chapter will cover the basic construction of the human face and figure and how to adapt it for a more heroic look. The second half will examine what well-dressed heroes wear and the weapons and accessories they carry.

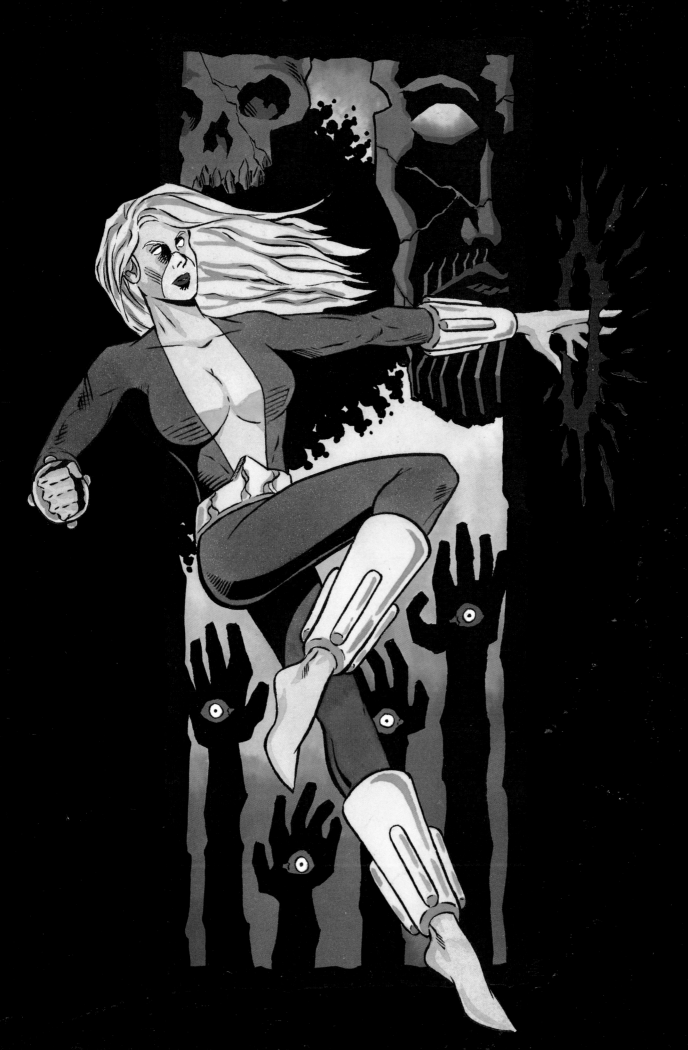

Male Head, Front View

The ability to draw the head correctly can make or break your art. Here you'll learn to draw a head of average proportions which you can then use as your basic template. Establish a general appearance before moving on to the specifics. Then be willing to experiment and have fun!

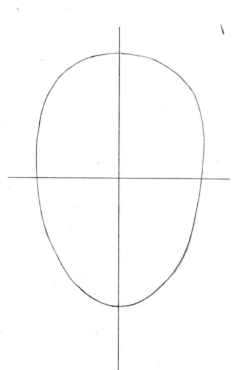

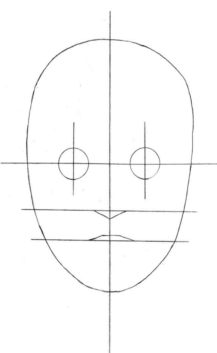

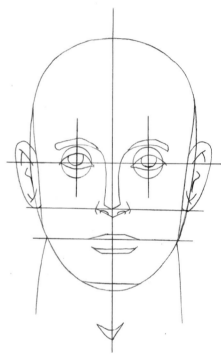

1 Lightly sketch an egg shape. A thinner egg makes a longer, leaner face, while a wider egg makes a heavier, huskier one. Add a horizontal line across the center for the eyes. Draw a vertical line down the center for placement of the nose and mouth. These are called *guidelines*.

2 Indicate the eye placement, then add a line for the nose and another for the mouth a little over a third of the distance from the nose to the chin. Add the eyeballs, the nose and the upper lip. The eyeballs should be small enough to fit five across the face.

3 Add the brow and the nose bridge. Place the top of each ear slightly above the eyebrows, with the bottoms ending near the nose line. Add eyelids, nostrils and the nose's outer wings. Keep the neck's thickness proportionate to how heavy or muscular your hero is. Super-muscular heroes have necks that bulge at the sides.

Indicate the iris and fill out the eyebrows. Rough in the contours of the outer ear and detail the inner ear. Indicate a small shadow beneath the lower lip, then add a small shadow for the Adam's apple.

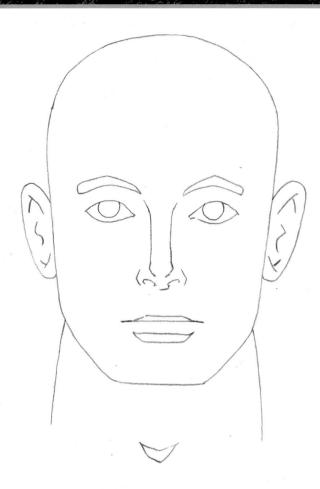

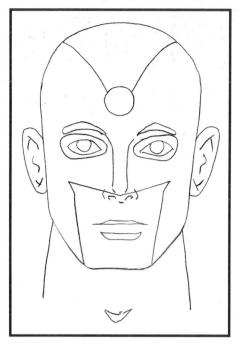

4 Erase the guidelines, then darken the remaining drawing. If your hero wears a mask, this is the time to rough it in, especially if your mask covers the hair.

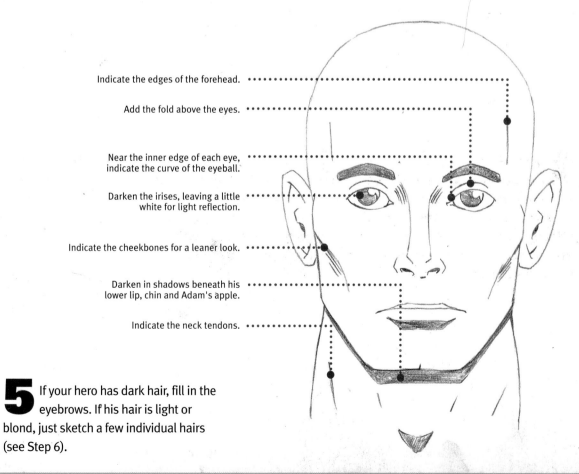

Indicate the edges of the forehead.

Add the fold above the eyes.

Near the inner edge of each eye, indicate the curve of the eyeball.

Darken the irises, leaving a little white for light reflection.

Indicate the cheekbones for a leaner look.

Darken in shadows beneath his lower lip, chin and Adam's apple.

Indicate the neck tendons.

5 If your hero has dark hair, fill in the eyebrows. If his hair is light or blond, just sketch a few individual hairs (see Step 6).

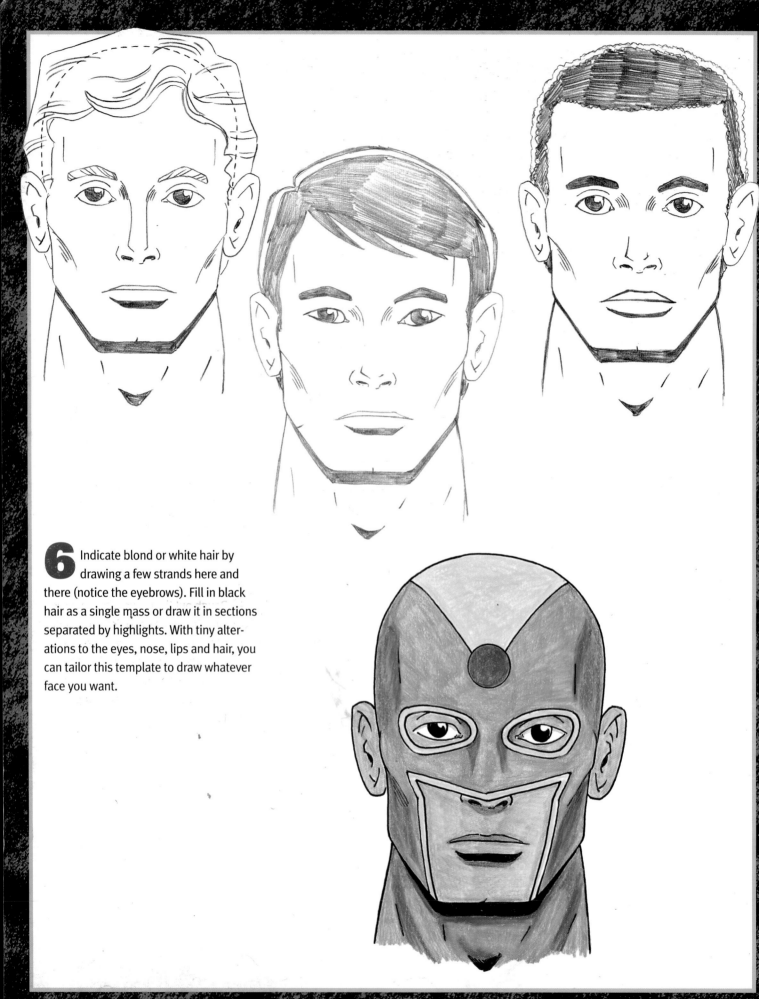

6 Indicate blond or white hair by drawing a few strands here and there (notice the eyebrows). Fill in black hair as a single mass or draw it in sections separated by highlights. With tiny alterations to the eyes, nose, lips and hair, you can tailor this template to draw whatever face you want.

Male Head, Profile

While the front view of the face has mainly symmetrical features—pairs of eyeballs, nostrils and ears placed essentially in the same places on both sides of the face— the profile shifts the view to a single side. Many facial features become part of the outline and you have to pay attention to things like how far the nose sticks out, the width of the ear and the length of the back of the skull.

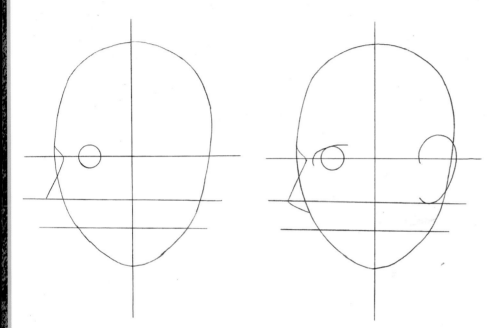 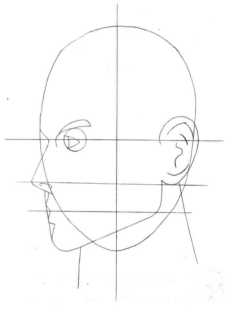

1 Draw the egg shape with the vertical and horizontal guidelines and add lines for the nose and mouth. Rough out the profile of the nose and place the eyeball slightly more than halfway between the vertical center line and the edge. Sketch the lower part of the nose, then indicate the eyebrow. Position the ear at the edge of the egg.

2 Rough out the jawline. Indicate the eyelids and begin to detail the outer ear. Add the nostril and indicate the profile of the lips. Indicate the iris and detail the inner ear. Add the lip indentations to the profile and fill out the eyebrow. Rough in the neck.

3 Detail the lips and outer wing of the nose and indicate the fold above the eye. Rough in the slight bulge near the back of the head.

Indicate the Adam's apple and add a few lines for the cheekbone, temple and neck muscles.

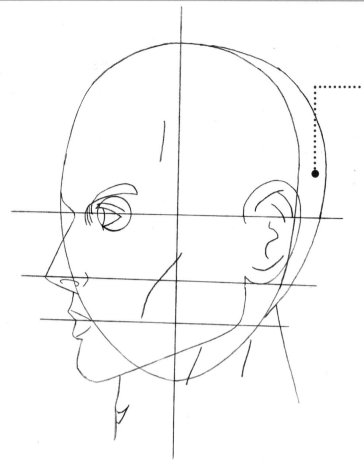

That slight bulge near the back of the head is part of the *parietal* and *occipital* bones. Impress your friends with your super-smarts!

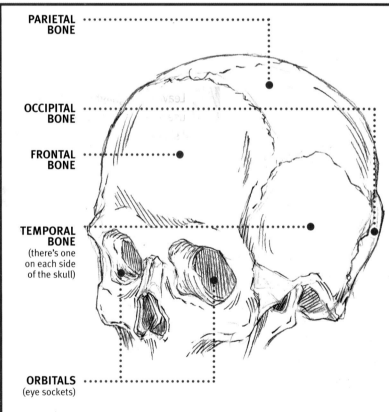

PARIETAL BONE

OCCIPITAL BONE

FRONTAL BONE

TEMPORAL BONE (there's one on each side of the skull)

ORBITALS (eye sockets)

The skull is actually a series of bones fused together.

From the top you can see the seams where the bones fuse together to form the skull.

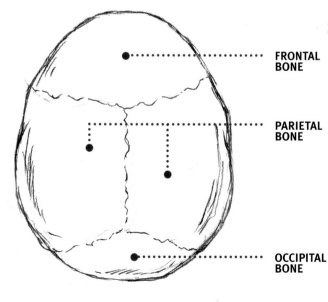

FRONTAL BONE

PARIETAL BONE

OCCIPITAL BONE

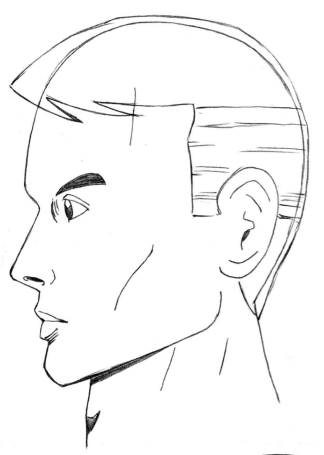

4 Erase the guidelines and other unnecessary lines, then strengthen the remaining ones. If your hero wears a mask, indicate it here. Sketch the hair and darken in the shadows.

5 Leave the highlights white and use darker shades to create the cast shadows.

Male Head, 3/4 View

The 3/4 view is the most interesting of the three major views and the hardest to draw. Unlike the more static feel of the full and side views, this angle almost always gives off a sense of movement.

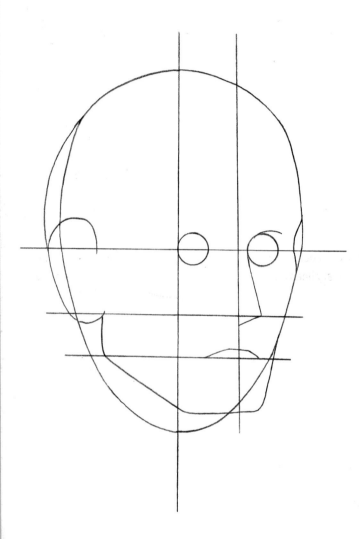

Because the head curves, the outer edge of the eye is hidden in a 3/4 view.

Likewise, the other nostril is hidden in a 3/4 view.

1 Draw your regular egg shape bisected by guidelines. Add another vertical line between the center line and the edge of the egg. This line will be the center of the 3/4-view face.

Rough in the profile and jawline. Indicate the nose, the upper lip and the ear. Add a slight skull bulge (that occipital bone again).

2 Sketch the brow and the nose bridge, then indicate the lower lip. Add the outer contours of the ear. Add detail to the inner ear and indicate the Adam's apple.

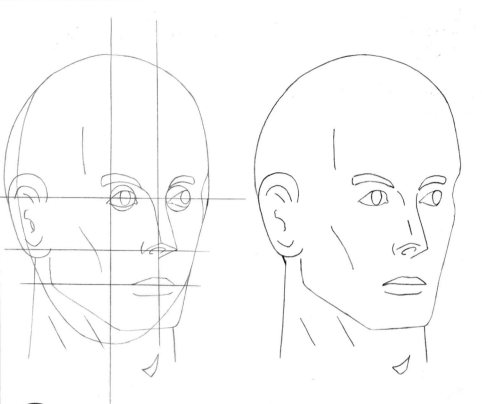

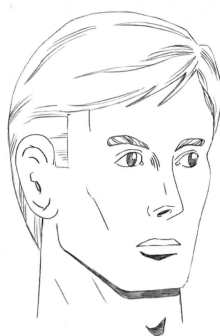

3 Add the irises and fill out the eyebrows. Add the nose's outer wing. As before, indicate the temple, cheekbone and neck muscles. Erase the unnecessary lines and add the mask if your hero wears one.

4 Add the fold above the eyelid and indicate the hair. Darken the eyes and the shadows beneath the lower lip and chin.

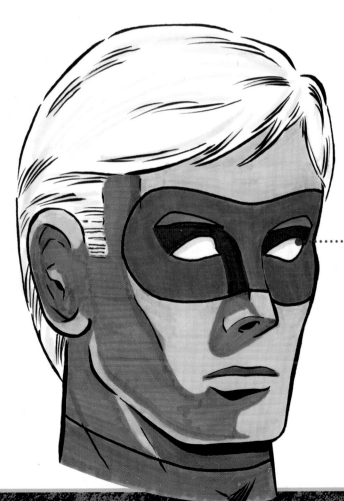

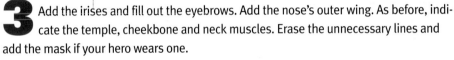

Leave out the pupils of your masked heroes to make them more mysterious.

5 The presence of shadows, whether they're done in black ink or in color, implies the presence of light, especially if the shadows are confined to a single area. In this case, because all the shadows are on the left side of the face, we assume there's a strong source of light coming in from the right.

Female Head, Front View

In general, drawing a female hero's head is the same as drawing a male's. The female's is just a little smaller.

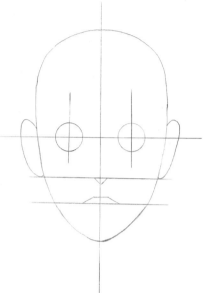

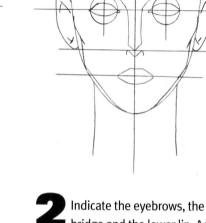

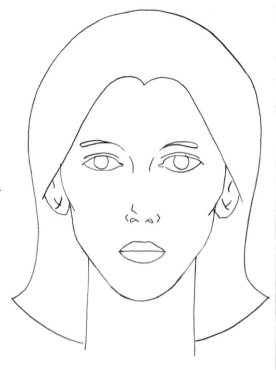

1 After you draw the shape and the guidelines, lightly sketch where the eyeballs, nose, upper lip and ears will go. For most heroines, the nose is a little smaller and the lips a little fuller than the male's.

2 Indicate the eyebrows, the nose bridge and the lower lip. Add the outer contours of the ears. Most heroines are thinner than their male counterparts, so draw their necks thinner and straighter.

Draw the more rounded chin and a slimmer jawline. Add the eyelids and begin to detail the nose, keeping the nostrils smaller than the male's. Remember, females don't have Adam's apples.

3 Sketch in her irises. Draw the thinner eyebrows. Finish detailing the inner ear and the outer wings of the nose.

Erase the guidelines and draw the shape of her hair. Indicate the folds above her eyes. Add a mask if she has one.

HAIR DO'S AND DON'TS

Drawing each strand of hair would be nearly impossible and very time-consuming, so most comic artists only deal with hair's overall style and color. Draw straight light-colored hair (blonde or white) with a few lines curving down along the skull and falling straight down the sides. Dark hair is a little harder, and is usually indicated as clumps of black with straight highlights interspersed throughout. Drawing wavy hair is much the same as straight except, of course, with the addition of curves. Curly hair is essentially a series of circles clumped together; the smaller the circles, the tighter the curls.

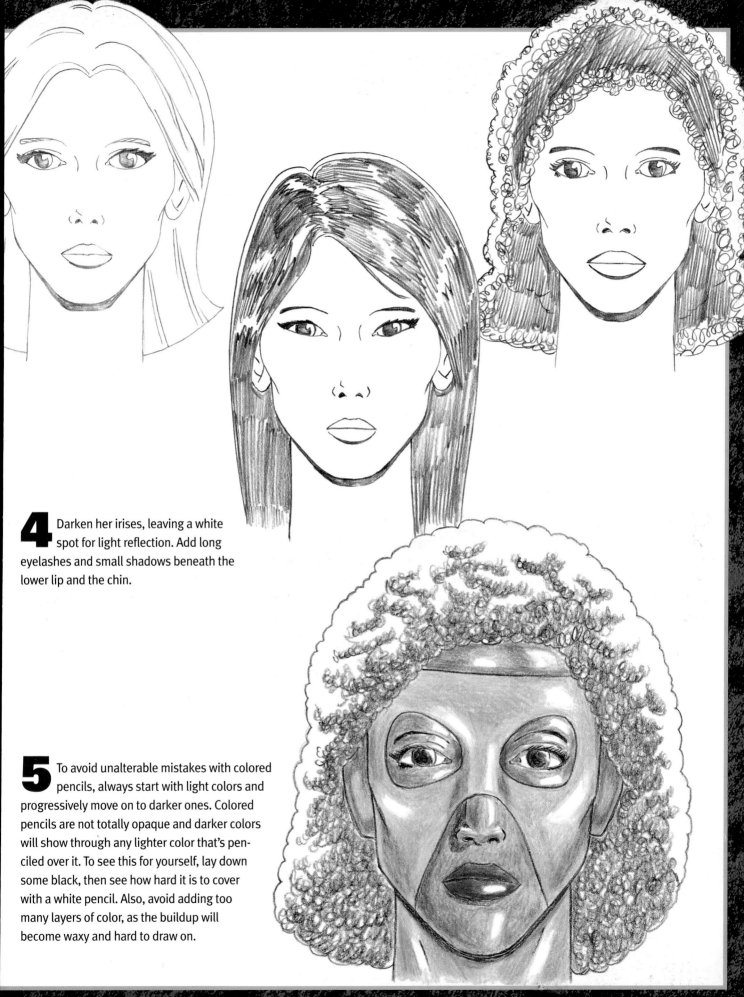

4 Darken her irises, leaving a white spot for light reflection. Add long eyelashes and small shadows beneath the lower lip and the chin.

5 To avoid unalterable mistakes with colored pencils, always start with light colors and progressively move on to darker ones. Colored pencils are not totally opaque and darker colors will show through any lighter color that's penciled over it. To see this for yourself, lay down some black, then see how hard it is to cover with a white pencil. Also, avoid adding too many layers of color, as the buildup will become waxy and hard to draw on.

Female Head, Profile

ust like in the male profile, many of the facial features are now a part of the outline. Soften that outline a bit to give the appearance of femininity.

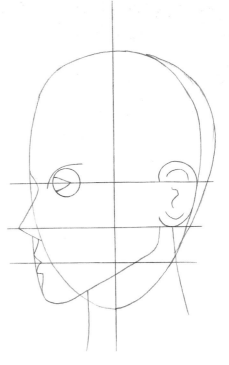

1 Begin as before with the head shape, guidelines and placement of the eyeball and the ear. Rough in the jawline, keeping it smoother and slimmer than the male's. Indicate the brow above the eyeball and the outer ear. Detail the eyelids, lips and inner ear. Add the slim neck and indicate the bulge at the back of the skull.

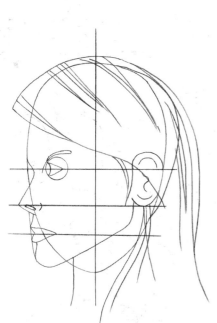

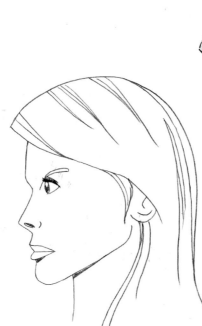

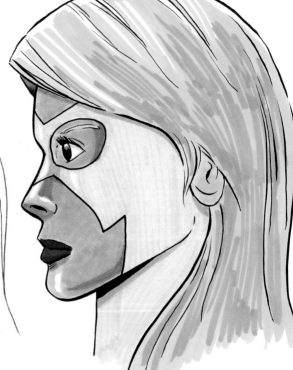

2 Detail the iris and fill out the eyebrow. Add the nostril and indicate the nose's outer wing. Add lips and hair.

3 Erase the guidelines and darken the eyelashes and the iris. Add shadows to the nostril, the lower lip and under the chin.

4 As you add color, remember to darken the colors along the bottom of the nose, lips and chin where the shadows will be for depth.

Female Head, 3/4 View

Like the male 3/4 view, this a more challenging position to draw. Draw a softer, less angular line for the jaw and a slimmer neck to give your drawing a more feminine look.

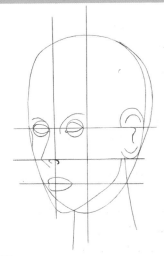

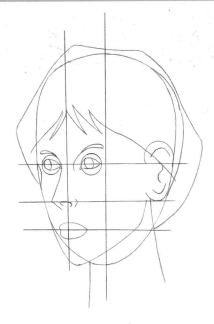

1 After you create the basic shape, refine the shape of the face and the jawline and indicate the features. At this angle, only the near side nostril is visible. Detail the ear and add the bulge at the back of the skull.

2 This character has a ponytail, so draw the hair shorter at the skull base. Add the irises and fill out the eyebrows. Indicate the wing of the nose and detail the ear.

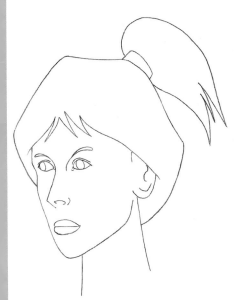

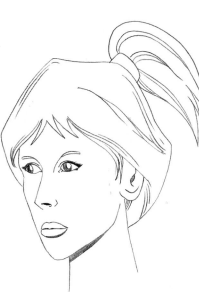

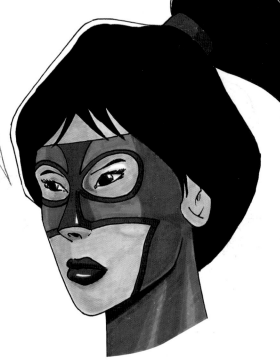

3 Erase the guidelines and darken your remaining pencil lines. Indicate the fold above her eyes and add her ponytail.

4 Darken her irises, leaving a highlight, and add eyelashes. Darken the shadows of the nostril, the lower lip and under the chin. Add a few strands to suggest the hair's texture.

5 Instead of just laying down one flat color for the mask, add a little trim around the mouth, nose and eye openings.

EXPRESSIONS—THE EYES HAVE I

Whether your heroes are thrashing a villain in righteous anger or happily eating ice cream, their faces should show it. In comic art, mood shows mainly through facial expression, so pay close attention to the way people look when they're happy, sad or angry. Better yet, get a mirror and study how the muscles in your face shift when you smile or frown.

Eyes convey emotion and attitude better than any other single facial feature. Study the following examples of how the eyes and the brows work together to create emotion.

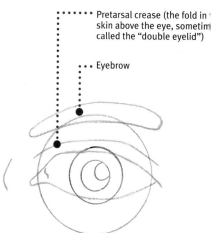

Pretarsal crease (the fold in skin above the eye, sometim called the "double eyelid")

Eyebrow

Basic Eye Construction
The eye consists of a ball (the eyeball) with a sheath of skin lying over it (the eyelid). The brows tend to rest just above the ball.

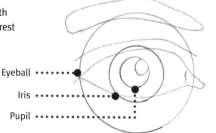

Eyeball
Iris
Pupil

Angry Eyes
Brows slash towards the center of the face making the muscles constrict and forming lines on the forehead and between the eyes. The eye also squints a bit, causing wrinkles at the outer edges.

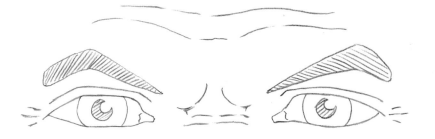

Shocked or Surprised Eyes
Eyes open wider than normal causing the white to show around the iris. The eyebrows shift higher on the forehead and the pupils contract, sometimes looking like little dots.

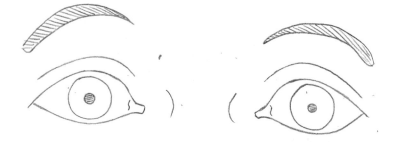

Sad Eyes
The eyebrows lift in a slight upside-down "U" shape towards the center of the face, causing wrinkles on the forehead. Curving the forehead wrinkles upwards slightly will add to the effect.

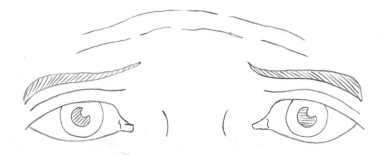

Annoyance

The eyes are narrowed and the brows arch higher in the middle, then slant to the center of the face. The line of the mouth is shorter than normal.

Malicious Grin

The eyes and mouth are set up like a suspicious expression, but one side of the mouth ends in an upturn.

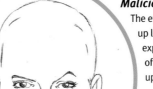

Anger

Lines form around the mouth. The lips are tightly shut and curved downward, and the shadow of the lower lip curves down slightly.

Suspicion

One eye and brow narrows; the other opens slightly wider, the brow rising up. The line of the mouth rises on one side, but the corners of the mouth dip down. A wrinkle from the nose to the edge of the mouth adds to the feeling of doubt.

Rage

Slant the eyebrows as with anger, but add more wrinkles to the face. The more wrinkles, the greater the stress. The mouth screams with the upper and lower lips curved in. Teeth, saliva, big cheekbones and the lines around the mouth show intensity.

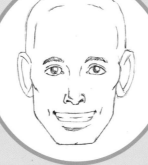

Happiness

The eyebrows raise and the forehead clears. The mouth is slightly open and curved up, as is the shadow of the lower lip. Add dimples at the sides of the mouth to accent the smile.

Surprise

The mouth opens to an "O" shape causing the cheeks to stretch and hollow so the lines around the cheekbones stand out.

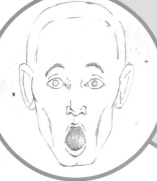

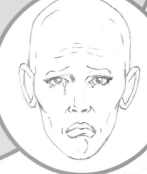

Crying

Crying eyes are slightly smaller than sad eyes. The line of the mouth curves downward and the eyes have tears in them. For added emphasis, add wrinkles around the edges of the nose, the mouth and the front of the chin.

Fear

The eyes are wider than normal and the brows rise up higher and curve upwards, forming wrinkles on the forehead. The mouth opens wider horizontally, showing teeth.

MUSCULATURE

The body has over six hundred individual muscles. Fortunately, you only need to know a few of these to effectively draw the human figure. The chart below indicates the main muscle groups. For more reference material, take a look through fitness and body building magazines.

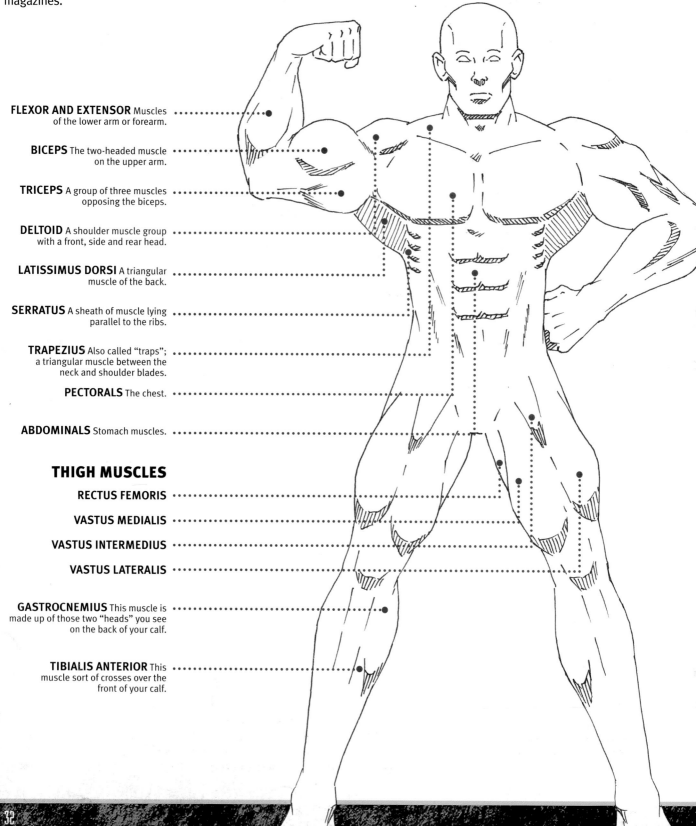

FLEXOR AND EXTENSOR Muscles of the lower arm or forearm.

BICEPS The two-headed muscle on the upper arm.

TRICEPS A group of three muscles opposing the biceps.

DELTOID A shoulder muscle group with a front, side and rear head.

LATISSIMUS DORSI A triangular muscle of the back.

SERRATUS A sheath of muscle lying parallel to the ribs.

TRAPEZIUS Also called "traps"; a triangular muscle between the neck and shoulder blades.

PECTORALS The chest.

ABDOMINALS Stomach muscles.

THIGH MUSCLES

RECTUS FEMORIS

VASTUS MEDIALIS

VASTUS INTERMEDIUS

VASTUS LATERALIS

GASTROCNEMIUS This muscle is made up of those two "heads" you see on the back of your calf.

TIBIALIS ANTERIOR This muscle sort of crosses over the front of your calf.

MEASURE BODIES WITH HEADS

The height of the head is used to fix the proportions of the body. The average height of a man is somewhere between 6 and 7 heads tall with a shoulder width of about 1½ heads. The height of a superhero's body is anything between 7 and 9 heads tall with a shoulder width of about 2 to 2½ heads. Any figure drawn taller or wider will begin to look distorted or musclebound, like the Incredible Hulk.

The average woman is 6 to 6½ heads tall. Again, superheroines are slightly taller, between 7 and 8½ heads.

To begin a figure, first choose a pose. Then lightly draw a basic structure, measuring by heads. This is just your preliminary guide, so draw it lightly. Use simple lines for the limbs and the spine. Indicate the chest and torso areas with rectangles and the hands and feet with small boxes.

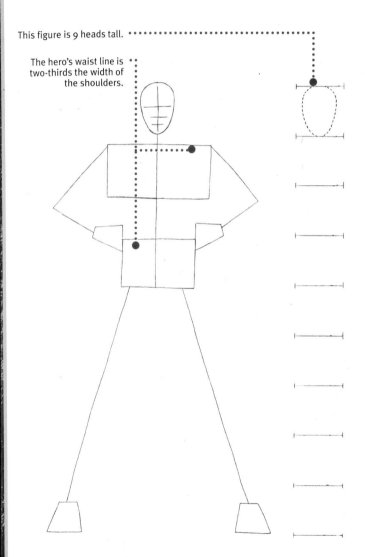

This figure is 9 heads tall.

The hero's waist line is two-thirds the width of the shoulders.

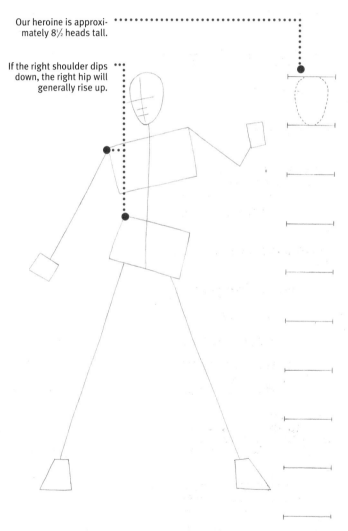

Our heroine is approximately 8½ heads tall.

If the right shoulder dips down, the right hip will generally rise up.

Male Hero Proportions
With the exception of Hulk-type characters, the waistline of a muscular male hero is no more than two-thirds the width of the shoulders.

Female Hero Proportions
Women's shoulder width is normally smaller than men's, while their hips are slightly larger. This makes the size ratio between the hips and the shoulders almost equal on the average woman. On a superheroine, the shoulders can be a tiny bit wider.

Male Superhero Figure

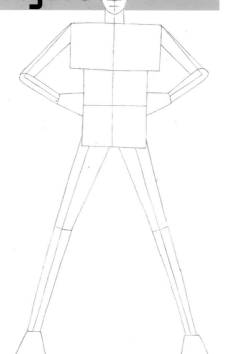

he first true comic book superhero, Superman, appeared in *Action Comics #1* in 1938. Superman was faster than an express train, could leap over a quarter-mile (.4 km), and had super-strength and impenetrable skin. He wore a skintight costume that showed off his physique, but, by today's standards, his musculature wasn't very well defined.

Today Superman has a variety of vision powers and is faster, stronger, and able to fly. His physical appearance has also improved. He's taller and broader in the shoulders. His waist is smaller and displays a set of washboard abs. This type of look is now the standard for male heroes.

1 Choose a pose and lightly pencil a basic stick figure. Use simple lines for the limbs and spine. Indicate the chest and torso areas with rectangles and the hands and feet with small boxes. Fill out the stick figure with tubing and indicate the knee and elbow joints. Position the facial features.

2 Surround the tubing with muscles. This hero is ultra-fit and ultra-strong, so make sure his muscles are well-defined.

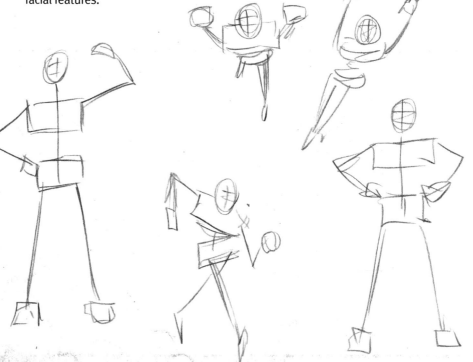

Begin With Thumbnail Sketches
Sketch thumbnails quickly. Don't spend too much time with any one drawing, as they're only meant to work out very basic issues. Before you begin, establish a clear mental image of what you want to draw.

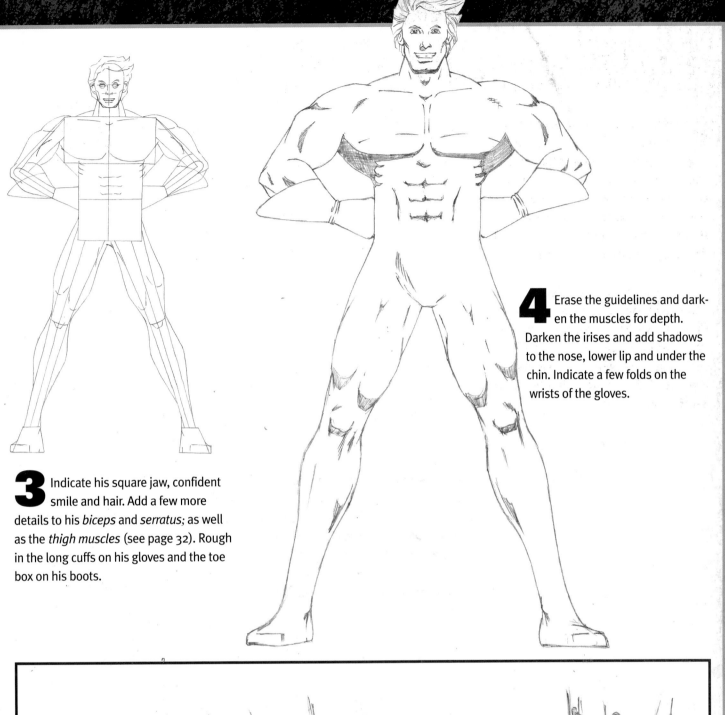

4 Erase the guidelines and darken the muscles for depth. Darken the irises and add shadows to the nose, lower lip and under the chin. Indicate a few folds on the wrists of the gloves.

3 Indicate his square jaw, confident smile and hair. Add a few more details to his *biceps* and *serratus;* as well as the *thigh muscles* (see page 32). Rough in the long cuffs on his gloves and the toe box on his boots.

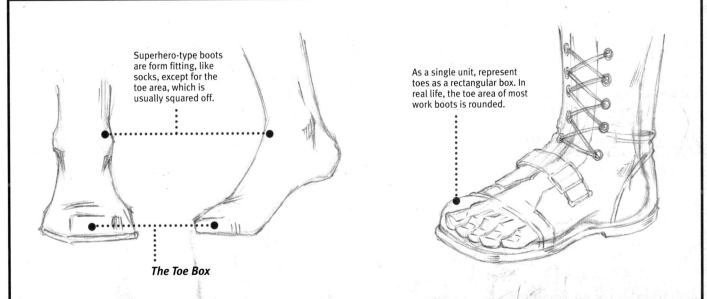

Superhero-type boots are form fitting, like socks, except for the toe area, which is usually squared off.

The Toe Box

As a single unit, represent toes as a rectangular box. In real life, the toe area of most work boots is rounded.

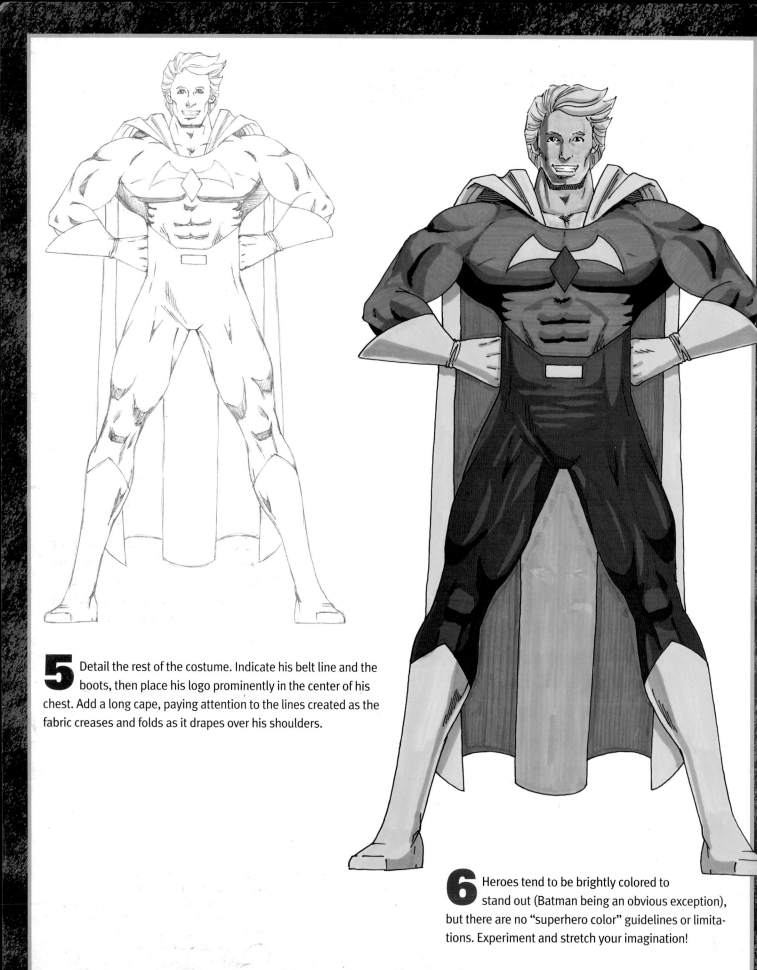

5 Detail the rest of the costume. Indicate his belt line and the boots, then place his logo prominently in the center of his chest. Add a long cape, paying attention to the lines created as the fabric creases and folds as it drapes over his shoulders.

6 Heroes tend to be brightly colored to stand out (Batman being an obvious exception), but there are no "superhero color" guidelines or limitations. Experiment and stretch your imagination!

Female Superhero Figure

eroines tend to be slightly smaller and less bulky than heroes. But they are definitely not weaker. Like her male counterpart, the female superhero figure has evolved from a more everyday standard to today's combination of a runway model and Olympic athlete. She is broad shouldered (although usually not as broad as the male's) and small-waisted, with tightly defined muscles (again, usually not as large as the male's) and long legs.

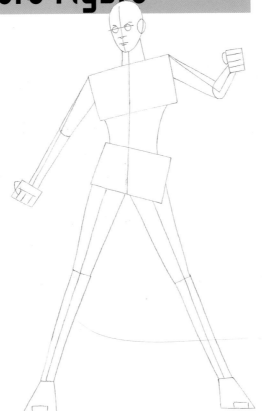

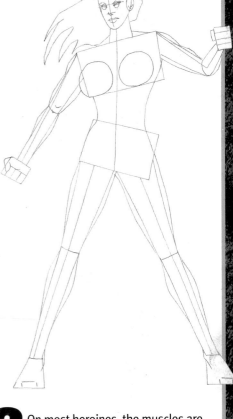

1 Pencil the basic stick figure, then fill it out with tubing, taking care to indicate the knee and elbow joints. Rough in the fists and the feet and place the facial features.

2 On most heroines, the muscles are not quite as large or defined as on heroes. Rough in the breasts and smooth out the lines connecting the shoulder and hip boxes. Indicate the hair and add some details to the face.

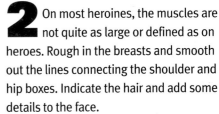

Begin With Thumbnail Sketches
As with every drawing, begin with thumbnails. At this stage the male and female figures are essentially the same, with only the proportion of the shoulders (usually a bit smaller) and the hips (usually a bit bigger) being different.

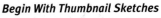

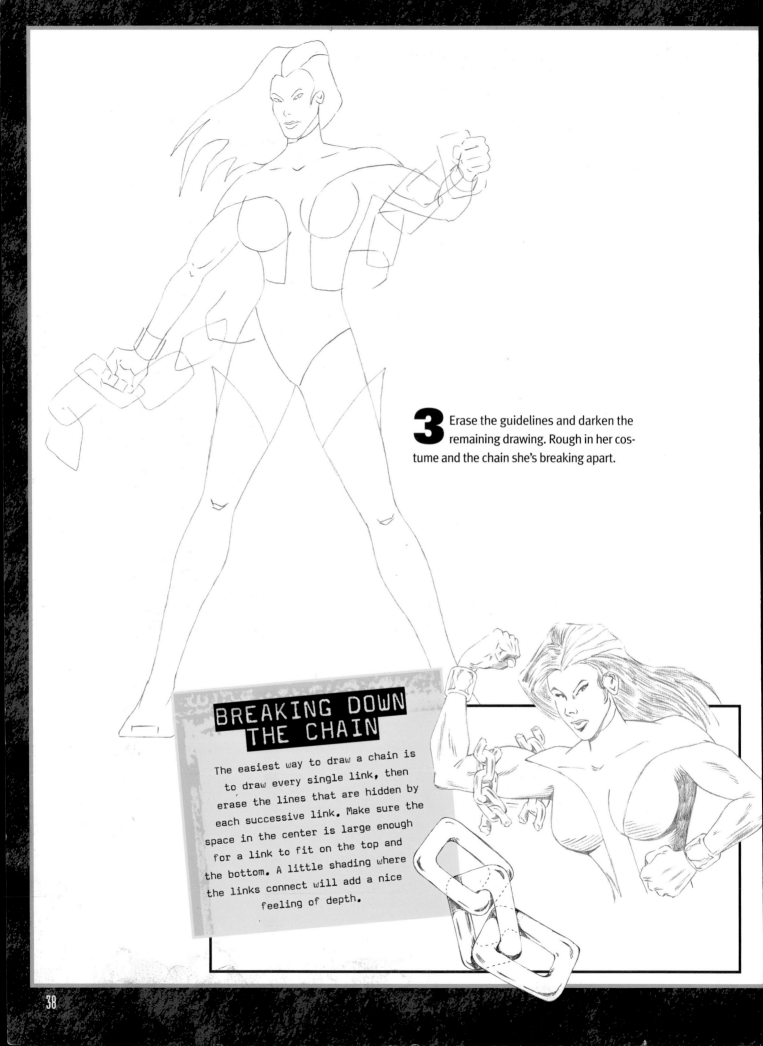

3 Erase the guidelines and darken the remaining drawing. Rough in her costume and the chain she's breaking apart.

BREAKING DOWN THE CHAIN

The easiest way to draw a chain is to draw every single link, then erase the lines that are hidden by each successive link. Make sure the space in the center is large enough for a link to fit on the top and the bottom. A little shading where the links connect will add a nice feeling of depth.

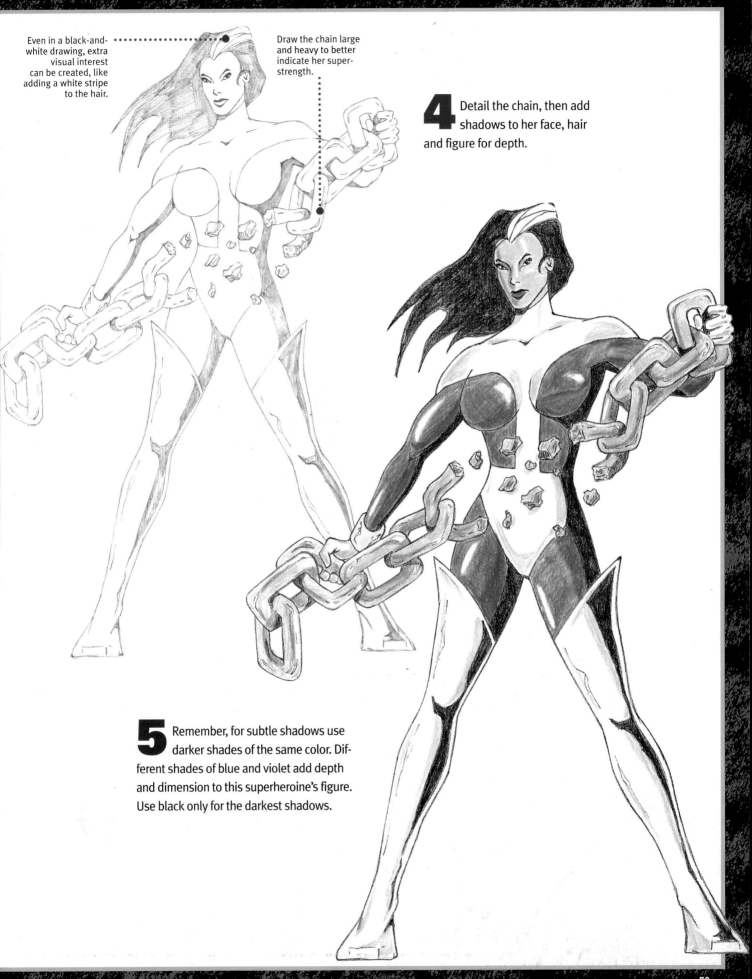

Even in a black-and-white drawing, extra visual interest can be created, like adding a white stripe to the hair.

Draw the chain large and heavy to better indicate her super-strength.

4 Detail the chain, then add shadows to her face, hair and figure for depth.

5 Remember, for subtle shadows use darker shades of the same color. Different shades of blue and violet add depth and dimension to this superheroine's figure. Use black only for the darkest shadows.

FORESHORTENING

Making your heroes leap out towards the viewer automatically adds excitement. This is accomplished through *foreshortening*, a drawing technique that makes certain objects appear much closer to the eye than others. The simplest way to draw foreshortened objects is to draw the closer object larger, then overlap it over the smaller background objects. Done correctly, this creates the illusion of depth or three-dimensionality in your art. To draw your hero's fist coming straight out at the viewer, draw the closer object, the fist, larger than normal. The fist then overlaps the forearm, upper arm and shoulder, giving a greater feeling of receding space.

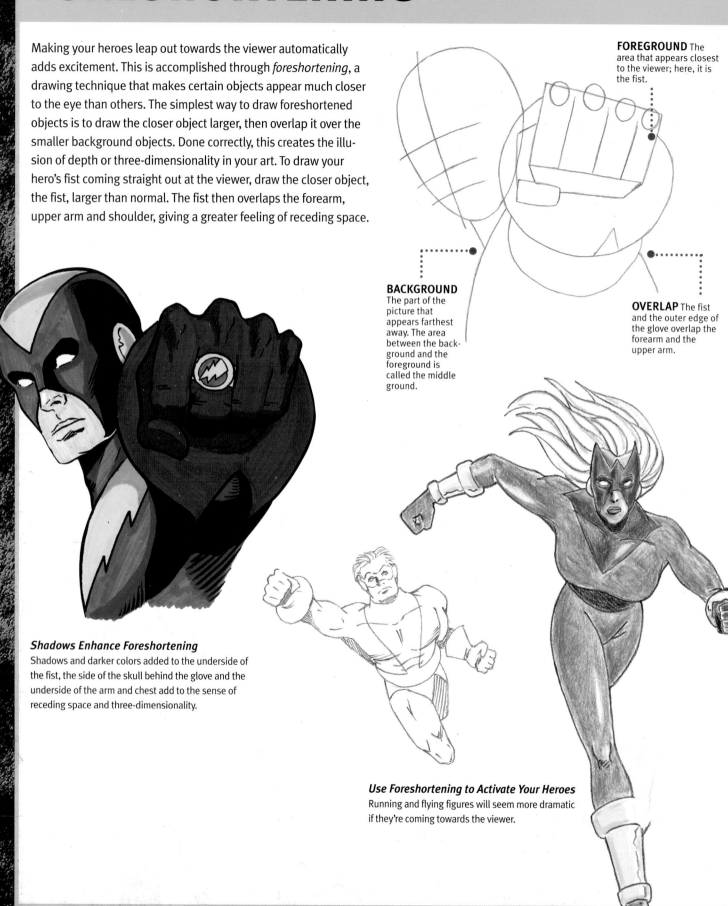

FOREGROUND The area that appears closest to the viewer; here, it is the fist.

BACKGROUND The part of the picture that appears farthest away. The area between the background and the foreground is called the middle ground.

OVERLAP The fist and the outer edge of the glove overlap the forearm and the upper arm.

Shadows Enhance Foreshortening
Shadows and darker colors added to the underside of the fist, the side of the skull behind the glove and the underside of the arm and chest add to the sense of receding space and three-dimensionality.

Use Foreshortening to Activate Your Heroes
Running and flying figures will seem more dramatic if they're coming towards the viewer.

HANDS

What do throwing a punch, firing a ray gun and eating a sandwich all have in common? They all involve hands. Whether your hero is shooting bolts of subnuclear energy from his fingertips or crushing mountains, you need to know how to draw his hands convincingly.

Look at your own hands. Notice how the fingers flex, how the skin moves around the joints and how the lines on your palm deepen.

Hand size tends to be a little larger than normal for the superhero, depending the character's bulk. For a hero like the Incredible Hulk, for example, the hands may be drawn as much as three times their normal proportions.

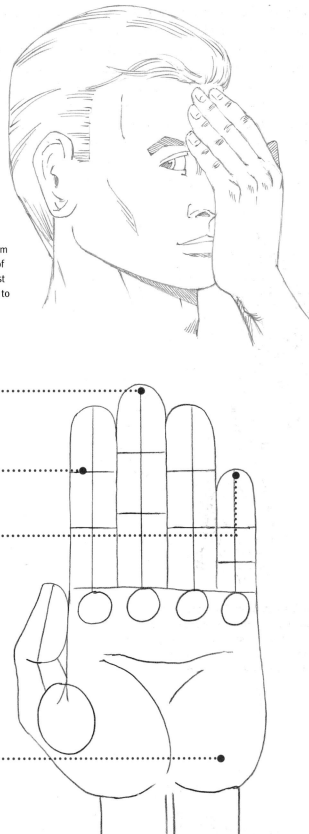

Is Your Hand as Big as Your Face?
Usually a person's hand, from the base of the palm to tip of the middle finger, will almost cover the face from the chin to the forehead.

The length of the middle finger is about the same as the length of the palm.

The joints of the first and third fingers tend to line up.

The tip of the little finger lines up approximately with the first joint of the third finger.

The palm of the hand is box-shaped. The longer the hand, the taller the box; the shorter the hand, the wider the box.

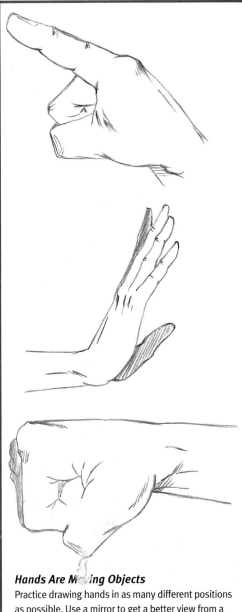

Hands Are Moving Objects
Practice drawing hands in as many different positions as possible. Use a mirror to get a better view from a wide variety of angles.

Drawing Hands

To draw hands, follow the same pattern you have used to draw everything else so far: begin with the basics, fill out the figure, erase the guidelines and add details.

BASIC FIST

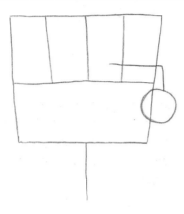

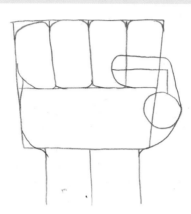

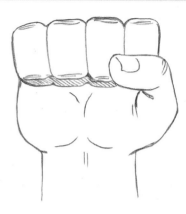

1 Draw the fist as a box. The folded fingers take up the top half of the box. The thumb cuts across the first finger and half of the second finger.

2 Fill out the thumb, then indicate the wrist. Round off the edges of the fingers and palm.

3 Erase the guidelines, then sketch in the folds and wrinkles on the joint areas of the fingers and thumb. Add the thumbnail, then indicate the folds on the palm.

FIST FROM THE FRONT

1 Begin this fist like a rectangle. The proportionate finger length is the same: The middle finger is the longest, the first and third fingers are next and the little finger is the shortest. The second knuckle rises up slightly higher than the rest.

2 Outline the skin over the knuckles, then indicate the bottom edge of the fingers. Add the upper edge of the thumb.

3 Add some shadows to show the shape of the knuckles, then erase the extras. Add the thumbnail, then the folds and wrinkles around the joints of the fingers and thumb. Go over the thumbnail and add shadows to the undersides of the fingers.

OTHER HAND STAGES

 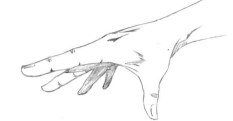

1 Use the same basic proportions to draw other hand stages. From this angle the palm has more of a wedge shape. Begin with that and add the joints of the forefinger and the thumb. Indicate the position of the fingers and the thumb with a skeletal guideline.

2 Surround the skeletal guidelines with tubing. Connect the inside of the forefinger's outline across the inner palm to the inside of the thumb's outline. Add tubing to the wrist and connect the outlines to the back of the hand and the thumb.

3 Erase the guidelines and add the finger and thumbnails. Indicate the folds and wrinkles around the finger joints. Add shadows to the third and fourth fingers for depth.

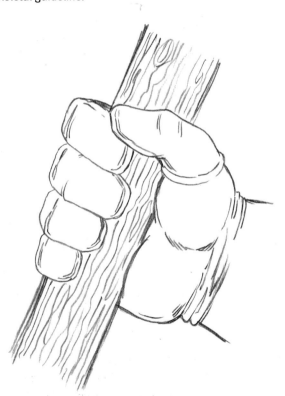

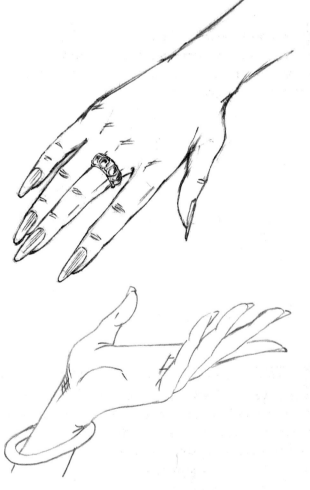

Hands in Gloves
Lots of heroes wear gloves. For a gloved hand, make the fingers a bit thicker and draw seams at the fingertips and thumb base. Add folds on the wrist for more realism.

Details Enhance Female Hands
Female fingers and wrists are usually more slender than males' and the bases of female palms aren't as thick. Accessories, such as longer, manicured nails and jewelry (rings, bracelets) can also help identify feminine hands.

FEET

Even though they're the last thing drawn and they're almost always at the bottom of the page, feet are just as important as any other body part. Whether your hero is bare-foot, booted, sandaled or kicking back in tennis shoes, you need to draw his feet with care and precision. Study your own feet and the shoes you wear. Notice how your toes squeeze together to fit into your sneakers, how the sides of the shoe curve inward towards your arch. Notice how your foot flexes with each step you take.

On the average person, the length of the foot is slightly longer than the height of the head. This proportion can vary greatly depending on your hero, but for most char-acters this formula is a good place to start.

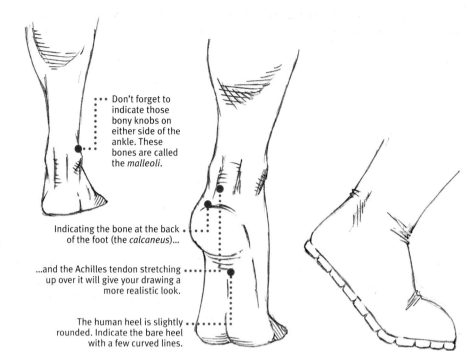

Don't forget to indicate those bony knobs on either side of the ankle. These bones are called the *malleoli*.

Indicating the bone at the back of the foot (the *calcaneus*)...

...and the Achilles tendon stretching up over it will give your drawing a more realistic look.

The human heel is slightly rounded. Indicate the bare heel with a few curved lines.

Superhero boots are often drawn like they're skin-tight, until they reach the toe box where the boot is squared off.

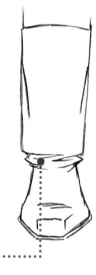

For a more realistic looking boot, extend it straight down and add folds around the ankle.

Heroine Footwear, Past and Present
In the past, the heroine's boot was usually drawn with a fashion-ably high heel and a pointed toe box. (Check out the footwear on Wonder Woman and Black Canary from the 1960s and 70s.) Today the heel and pointed toe are optional, but the foot and ankle are still drawn slimmer than the men's, especially on the skin-tight style of boot.

Drawing Feet

 earn to draw the foot from as many angles as possible. Pick up shoe and boot cata-logs for reference photos.

FEET, 3/4 VIEW

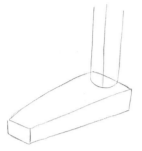

1 The foot is a rectangular wedge attached to the ankle.

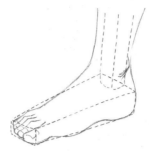

2 For bare feet, toes round off the front of the wedge, with the first two toes being the longest. Fill out the ankle and attach it to the wedge.

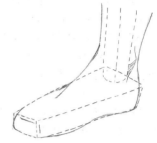

3 For a superhero boot, draw the ankle and the back of the foot as though it were bare, then draw the toe box.

FEET, SIDE VIEW

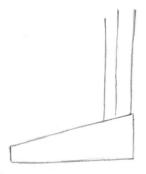

1 The side of the foot is a narrow, two-dimensional wedge.

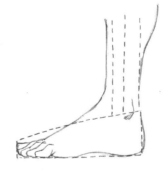

2 The toes take up the first quarter of the foot and the heel takes up the last quarter.

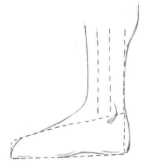

3 Draw the boot as though the ankle and the back of the foot were bare, then slightly round down.

FEET, FRONT VIEW

1 From the front, the wedge has a wider base, narrowing as it connects to the ankle.

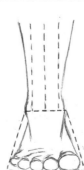

2 Foreshorten the toes so they look like flat ovals.

3 Again, draw the ankle like it's bare, then indicate the toe box. Add a small crease where the toes flex.

MALE COSTUMES

A good costume makes the hero (or villain). Skin-tight, colorful and apparently rip- and stain-resistant, the well-dressed hero's outfit enhances his character, making him more visually appealing.

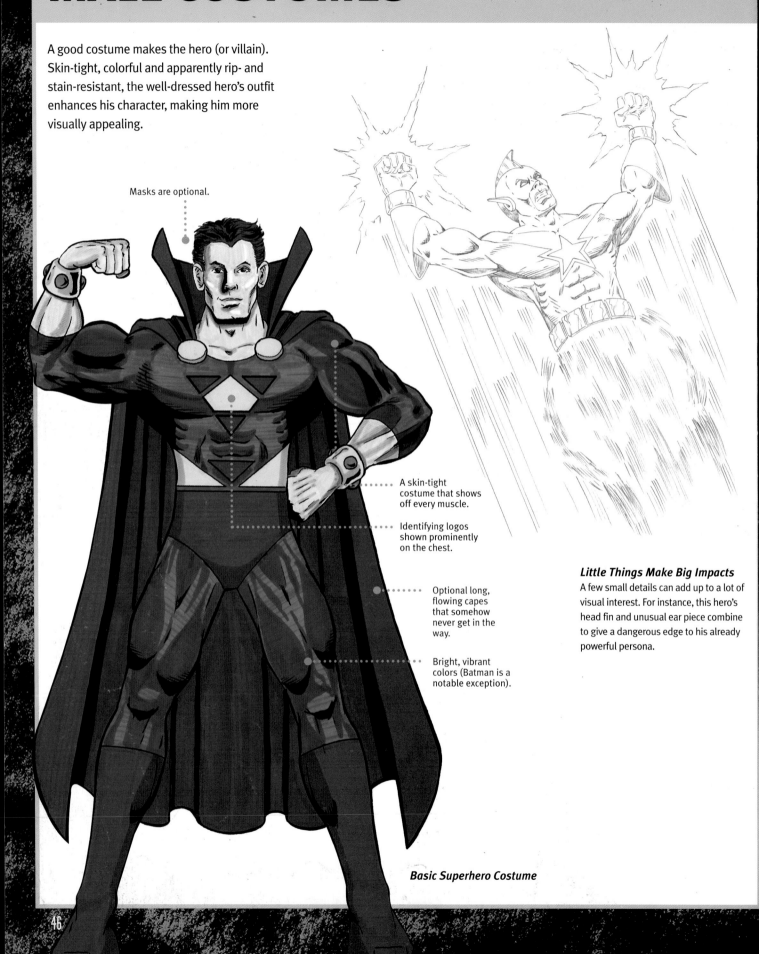

Masks are optional.

A skin-tight costume that shows off every muscle.

Identifying logos shown prominently on the chest.

Optional long, flowing capes that somehow never get in the way.

Bright, vibrant colors (Batman is a notable exception).

Little Things Make Big Impacts
A few small details can add up to a lot of visual interest. For instance, this hero's head fin and unusual ear piece combine to give a dangerous edge to his already powerful persona.

Basic Superhero Costume

FEMALE COSTUMES

A superheroine's costume should look attractive, while still being functional. An evening gown might look nice, but it's impractical for chasing criminals. These skin-tight outfits not only show off her muscles, but allow for complete freedom of movement. On rare occasions she may sport a short skirt and heels, but usually it's tights and flat, functional soles.

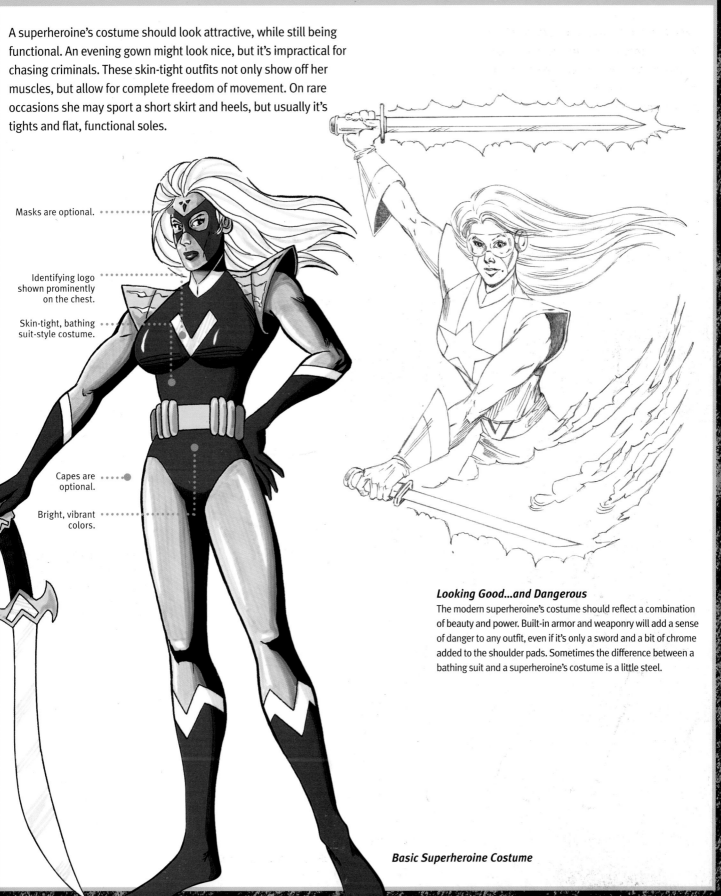

Masks are optional.

Identifying logo shown prominently on the chest.

Skin-tight, bathing suit-style costume.

Capes are optional.

Bright, vibrant colors.

Looking Good...and Dangerous
The modern superheroine's costume should reflect a combination of beauty and power. Built-in armor and weaponry will add a sense of danger to any outfit, even if it's only a sword and a bit of chrome added to the shoulder pads. Sometimes the difference between a bathing suit and a superheroine's costume is a little steel.

Basic Superheroine Costume

MASKS

In the world of superheroes and villains, there are four reasons for a mask:

1 To hide one's identity (example: Spider-Man).

2 To frighten your enemy (example: Batman).

3 It's functional. The mask acts as protection, contains a weapon or focuses the wearer's powers (examples: Dr. Mid-Nite, Cyclops).

4 It just looks cool (examples: every hero who wears a mask).

Half-Masks
Found mostly on Golden Age-type heroes, this type of mask covers just the eyes. Many artists leave the eyes completely blank. These are also called *eye masks*. Examples: Green Lantern, Robin.

Full-Face Masks
These cover all facial features. The eyes are usually blank, though sometimes the mask is drawn without any eye slits. On rare occasions, a full-face mask will be drawn with the facial features over it. Examples: Spider-Man, The Question, the Green Goblin.

3/4 Masks
This mask leaves the eye and mouth areas open. Covering the hair, ears and nose is optional. The eyes can also be drawn as white slits. Examples: Batman, Captain America, Huntress.

Steel Masks
A favorite of the disfigured villain and the armored hero, this mask generally covers the entire face. Thin, squiggly lines of varying width show the metal's reflective surface. Examples: Dr. Doom, Iron Man, Madame Masque.

Functional Masks
These masks may have defensive properties, act as a focusing agent for the hero's innate abilities or contain high-tech weaponry for the non-super-powered. They can be as simple as a visor or as complex as an entire arsenal affixed onto a helmet. Examples: Cyclops, the Unicorn, the original Sandman.

WEAPONS

It's tough work being a superhero (or a super villain, for that matter) if everyone else has more power than you. To even the odds, many costumed adventurers have equipped themselves with super-specialized ray guns, magic swords or cosmic staffs. Even the strongest heroes have been known to use a weapon to focus and augment their powers.

GUNS AND BOMBS

Cold guns, heat guns, ray guns, sound guns, gas guns, element guns, even glue guns—the variety of guns used by today's heroes and villains is endless.

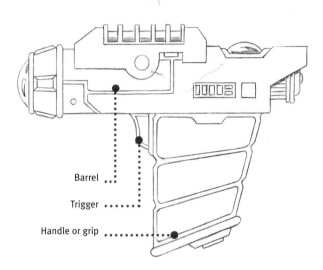

Barrel

Trigger

Handle or grip

When Is a Gun Not a Gun?
For your drawing of a gun to be readily identifiable as such, there are some requirements. The barrel needs an opening. Science-fiction guns don't need the opening, they can use satellite disc or a metal bulb to emit energy rays. You need a trigger, a small, curved piece of metal pulled by the forefinger. And the grip should be vertically attached to the gun's body.

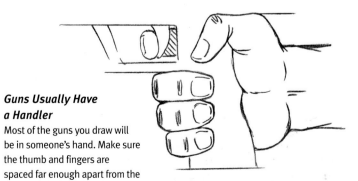

Guns Usually Have a Handler
Most of the guns you draw will be in someone's hand. Make sure the thumb and fingers are spaced far enough apart from the palm for the weapon's grip.

Experiment With Explosive Design
Hand-held explosives are favored mostly by nonsuper-powered villains, vigilantes and the criminally insane. Whether it's the Green Goblin's pumpkin bombs, the Joker's clown grenades, or a simple high-tech thermite detonator, explosive weaponry looks best when it's drawn in new and unusual ways.

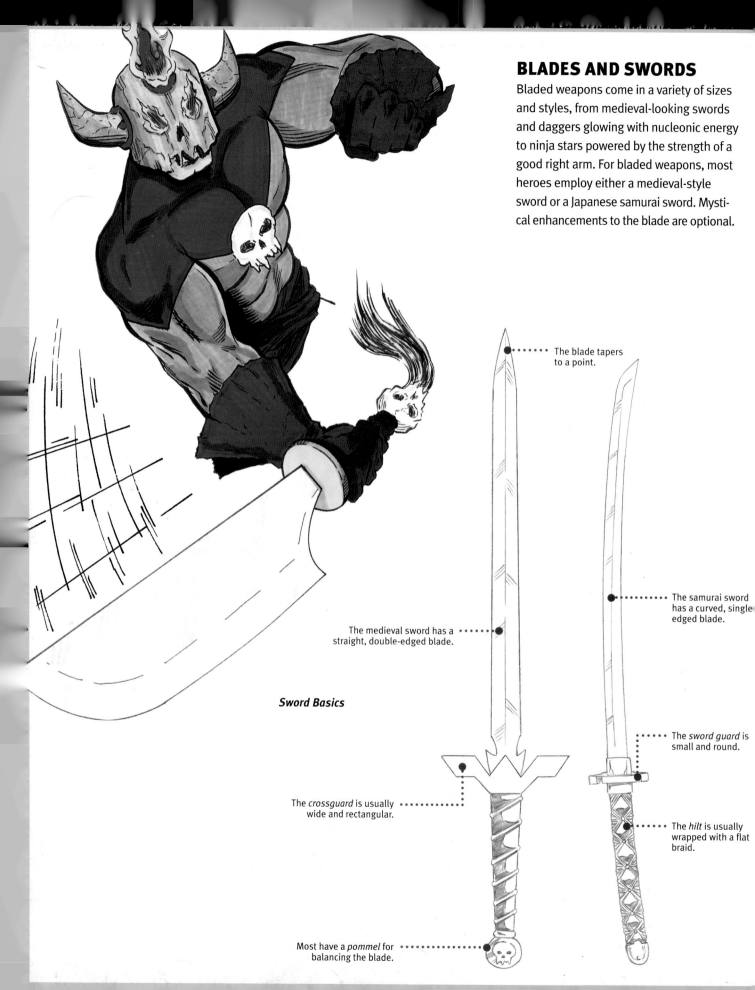

BLADES AND SWORDS

Bladed weapons come in a variety of sizes and styles, from medieval-looking swords and daggers glowing with nucleonic energy to ninja stars powered by the strength of a good right arm. For bladed weapons, most heroes employ either a medieval-style sword or a Japanese samurai sword. Mystical enhancements to the blade are optional.

The blade tapers to a point.

The samurai sword has a curved, single-edged blade.

The medieval sword has a straight, double-edged blade.

Sword Basics

The *sword guard* is small and round.

The *crossguard* is usually wide and rectangular.

The *hilt* is usually wrapped with a flat braid.

Most have a *pommel* for balancing the blade.

Throwing Daggers

Adding a little mystical aura or energy can make even a standard throwing knife look special.

Custom Knives

Even in real life knives come in a huge variety of styles. Vary your blade designs and add ornaments to the handles.

Throwing Stars

Draw these deadly spinning missiles (sometimes called *shuriken*) by sketching curved *motion lines* (see page 76) within a circle to indicate the device's spin and adding speed lines behind it to indicate the direction from which it came.

Exotic Blades

The look of your weapon is limited only by the amount of imagination you bring to your drawing of it. For inspiration, look up books on historical arms and armor from around the world.

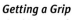

Getting a Grip

The thickness of a sword's grip varies depending on the size and weight of its blade. Make sure you draw your hero's hand large enough to fit around the grip. Add shadows to the parts of the fingers that will recede with the hilt to show depth.

ANCIENT WEAPONS

These may seem old-fashioned, but in the hands of a hero an old mace can become a nuclear-charged missile. From Hawkman to Thor, heroes have consistently used ancient weapons against modern foes.

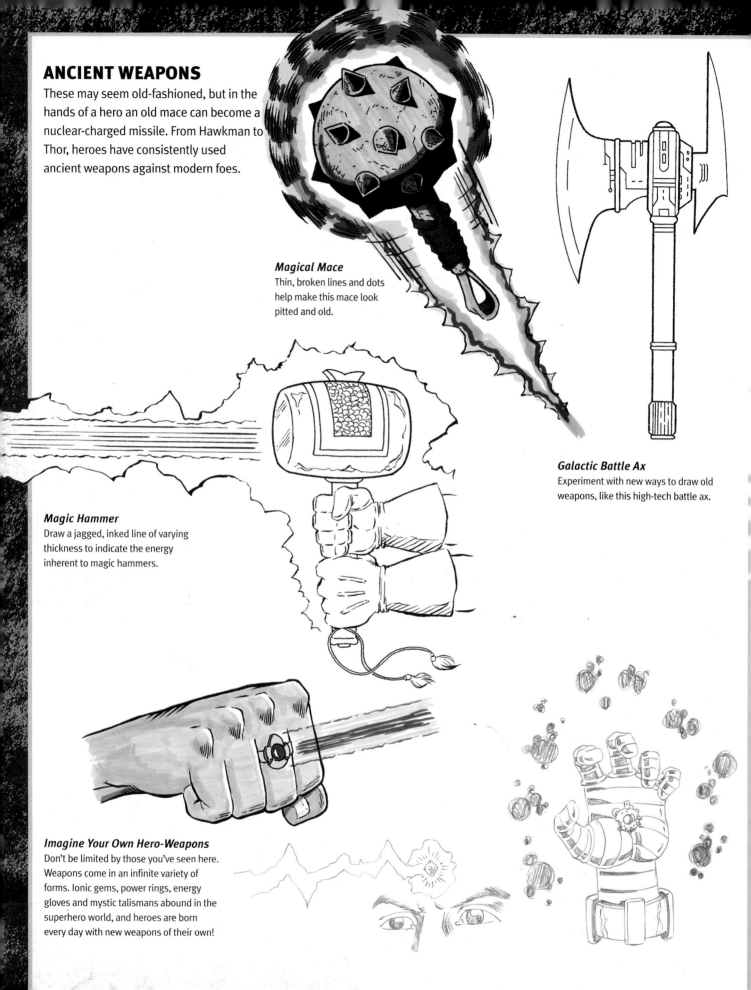

Magical Mace
Thin, broken lines and dots help make this mace look pitted and old.

Galactic Battle Ax
Experiment with new ways to draw old weapons, like this high-tech battle ax.

Magic Hammer
Draw a jagged, inked line of varying thickness to indicate the energy inherent to magic hammers.

Imagine Your Own Hero-Weapons
Don't be limited by those you've seen here. Weapons come in an infinite variety of forms. Ionic gems, power rings, energy gloves and mystic talismans abound in the superhero world, and heroes are born every day with new weapons of their own!

SHIELDS

Sometimes the best offense is a good defense, and for the last two thousand years, the best defense has been a shield. While general function and design hasn't changed much in that time, artists' imaginations have blossomed. You'll see heroes guarded with shields made from just about anything, from space age polymers to self-generated energy.

Standard Shield

Traditionally, a knight's shield would be decorated with his *coat of arms* (pictures that identified rank or family). Today's super-hero would probably display his own logo on it.

Modified, Modern Shield

Generally speaking, the back of a shield would have leather straps attached for the user to slip his forearm through. A superhero's shield might be attached by magnetism or even a mini-tractor beam (although Captain America still uses leather straps).

The Force Field is the Best Shield of All

If your hero is not lucky enough to be invulnerable like Superman, then he'd better have a good force field handy. When you're just using pencils or inks, indicate an invisible force field with a dotted line.

Enhance Your Force Field's Look With Color

A light, transparent line of color shows your force field. If your hero wants to show off a bit, draw bolts of power bouncing off it.

2

HEROES, VILLAINS, POWERS AND PLACES

N ow that you've mastered the basics, it's time to put it all together and create some super-powered art. In this section you'll apply the skills you learned in Part 1 to create a wide variety of heroes and villains. You'll also learn a few of the drawing techniques used to depict super powers and other special effects.

Use these characters as practice as you hone your skills. Feel free to alter, adapt or change any part of them to suit your needs. Experiment with different costumes, powers and looks until you've created your very own league of superheroes.

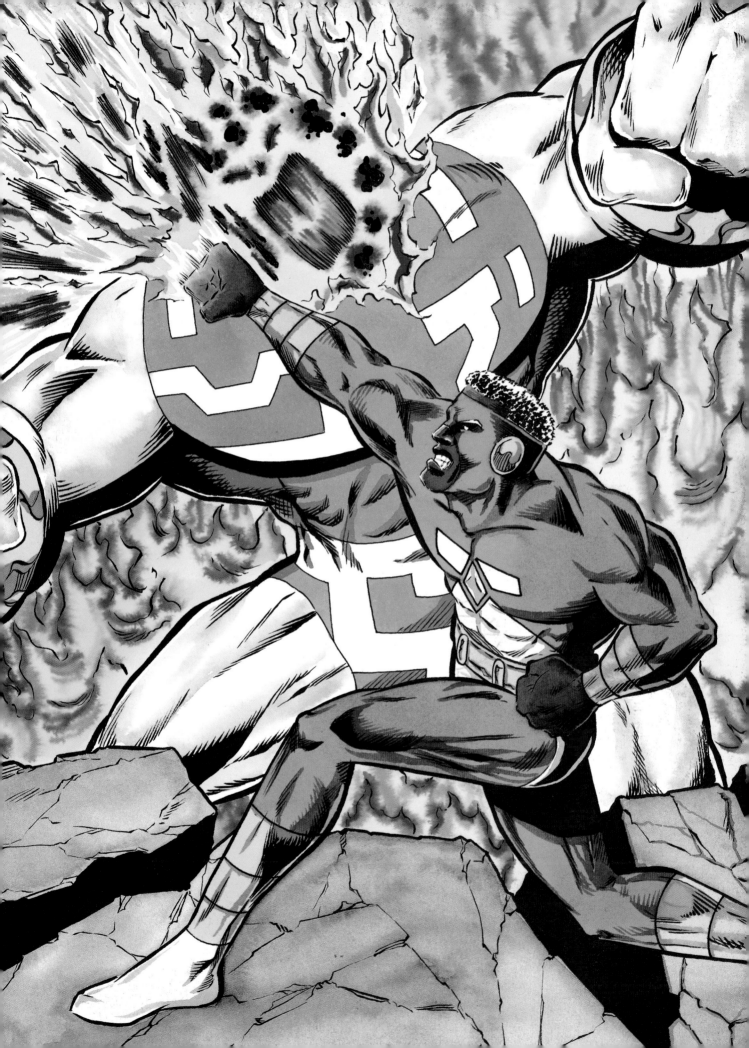

DRAWING SUPER POWERS

You usually don't have superheroes without super powers of some sort. It's one of the first things you should think about before you begin to draw. Bolts of glistening energy rage from your hero's fingertips, a mutant brain spews a storm of telekinetic power, a heroine becomes one with the cosmos...but how the heck do you draw it all? The following are some popular ways to portray super powers. But don't limit yourself to just these—experiment! Find new ways to draw old things. Remember, *your* super power is your imagination.

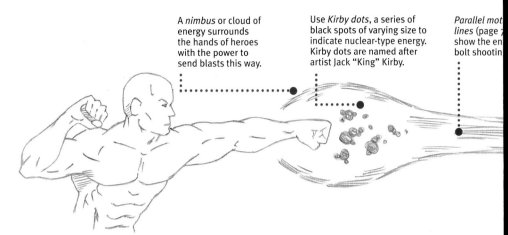

A *nimbus* or cloud of energy surrounds the hands of heroes with the power to send blasts this way.

Use *Kirby dots*, a series of black spots of varying size to indicate nuclear-type energy. Kirby dots are named after artist Jack "King" Kirby.

Parallel mot[ion] lines (page 7 show the en[ergy] bolt shootin[g]

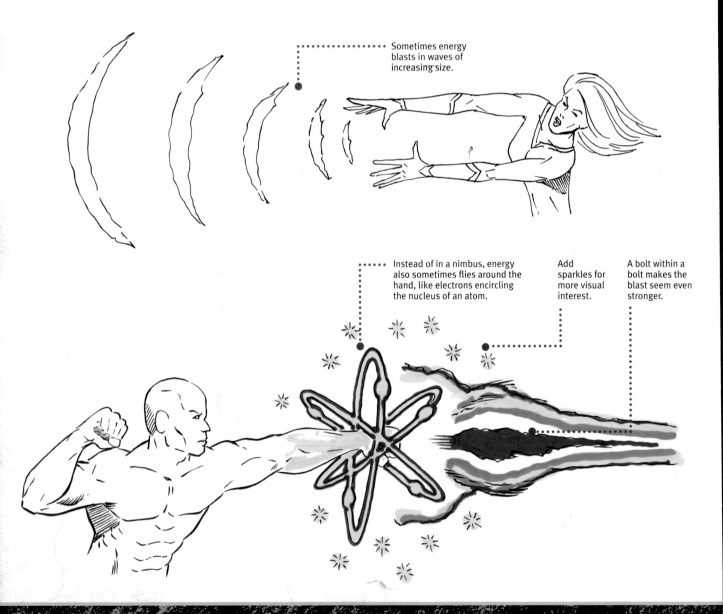

Sometimes energy blasts in waves of increasing size.

Instead of in a nimbus, energy also sometimes flies around the hand, like electrons encircling the nucleus of an atom.

Add sparkles for more visual interest.

A bolt within a bolt makes the blast seem even stronger.

56

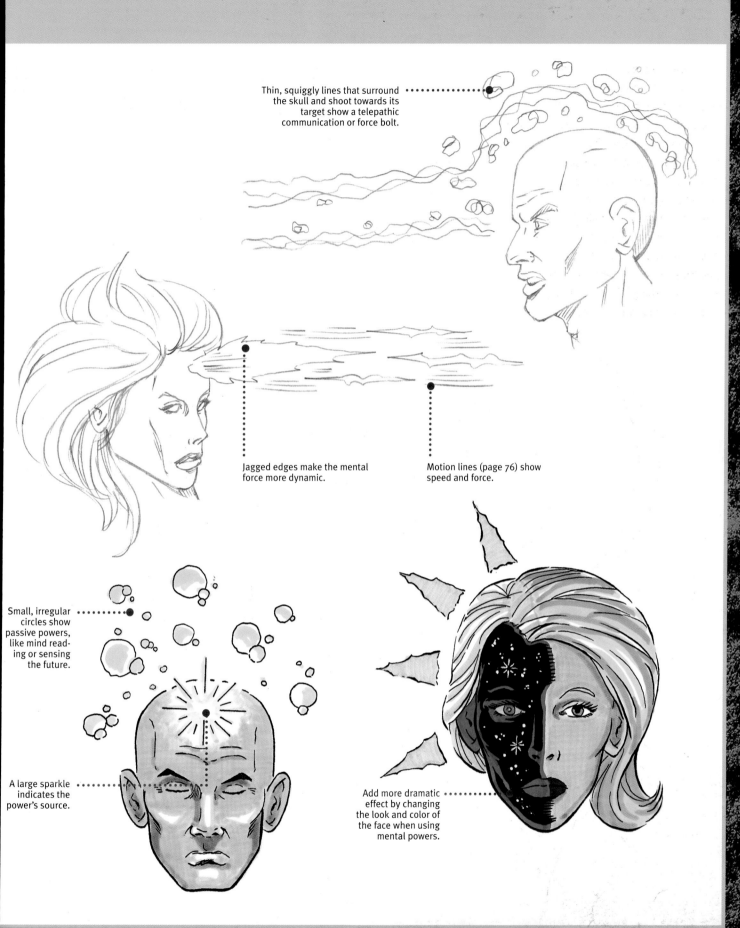

Thin, squiggly lines that surround the skull and shoot towards its target show a telepathic communication or force bolt.

Jagged edges make the mental force more dynamic.

Motion lines (page 76) show speed and force.

Small, irregular circles show passive powers, like mind reading or sensing the future.

A large sparkle indicates the power's source.

Add more dramatic effect by changing the look and color of the face when using mental powers.

Classic Hero Pose

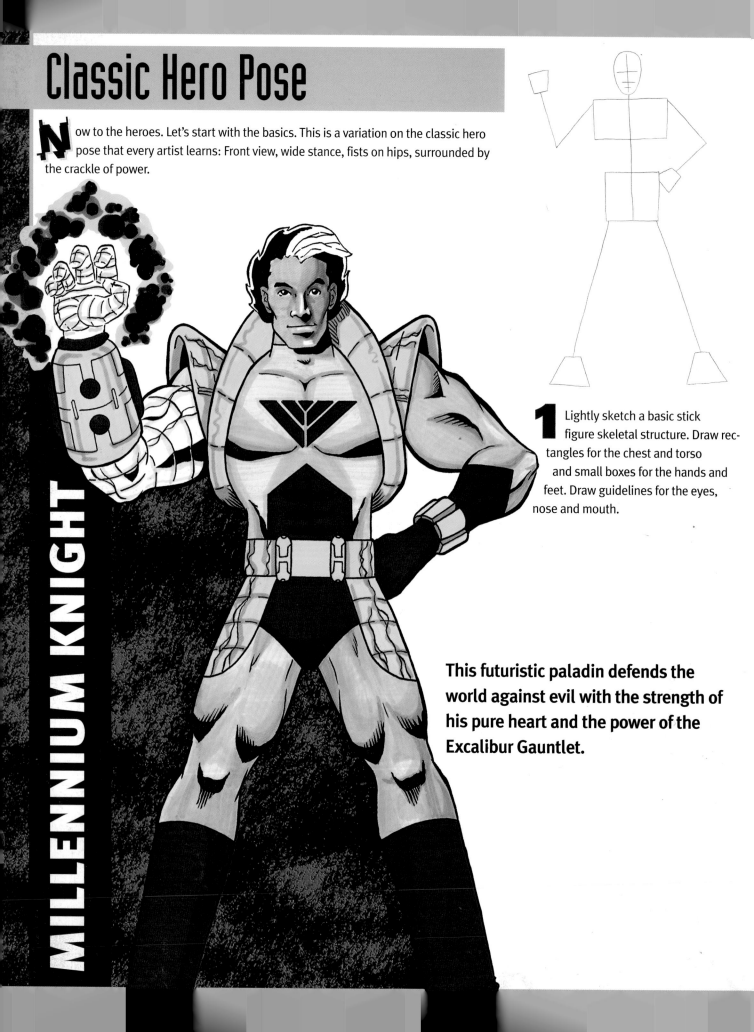

Now to the heroes. Let's start with the basics. This is a variation on the classic hero pose that every artist learns: Front view, wide stance, fists on hips, surrounded by the crackle of power.

MILLENNIUM KNIGHT

1 Lightly sketch a basic stick figure skeletal structure. Draw rectangles for the chest and torso and small boxes for the hands and feet. Draw guidelines for the eyes, nose and mouth.

This futuristic paladin defends the world against evil with the strength of his pure heart and the power of the Excalibur Gauntlet.

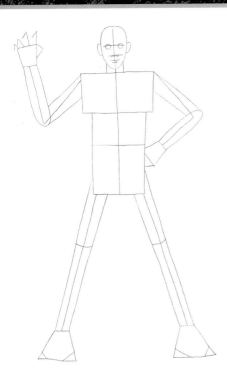

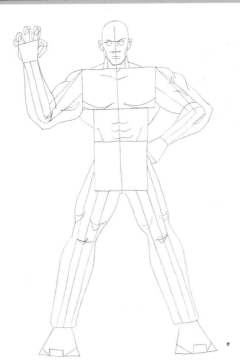

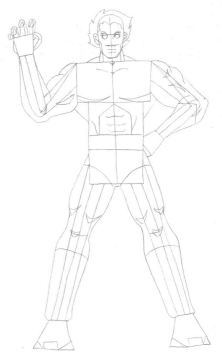

2 Add the tubing. Mark the knee and elbow joints. Add the eyeballs and lightly detail the nose, mouth and ears. Rough in the position of the fingers and indicate the contours of the feet.

3 Like most heroes, the Knight's muscles are large and well defined. Make sure his biceps, chest, abs and quads are plain to see (see page 32). Indicate his square jawline and cheekbones, then sketch the browline and the contours of his inner ear. Fill out his fingers and indicate the toe box.

4 Fill out the eyebrows, indicate his eye shape and detail his inner ear. Add a full head of wavy, windblown hair to enhance the dashing hero look. Lightly rough in the basic elements of the costume.

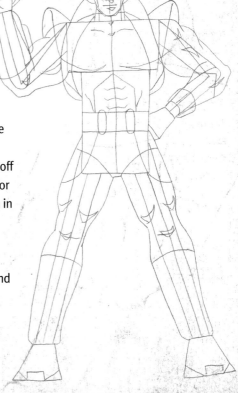

5 Add irises and indicate shadows underneath his nose and lower lip. Block off a section of hair to be white for visual interest. Lightly sketch in the body armor around his shoulders and neck. Add his gauntlet and wrist band, the power capsules on his belt and his armored hip pads.

COLOR TIPS

Begin with major colors, then add a little shading around the muscles and highlights on the armor. Light blue works best as a highlight against a white background, as in the case of the Knight's armored right bicep, and orange works well to highlight the yellow portions of his armor.

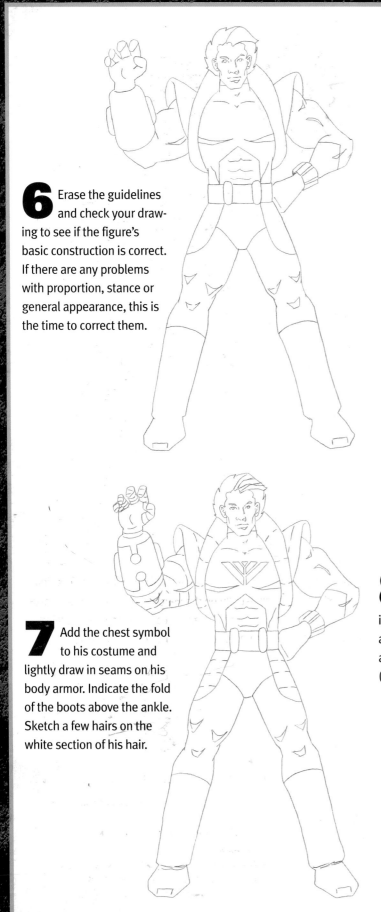

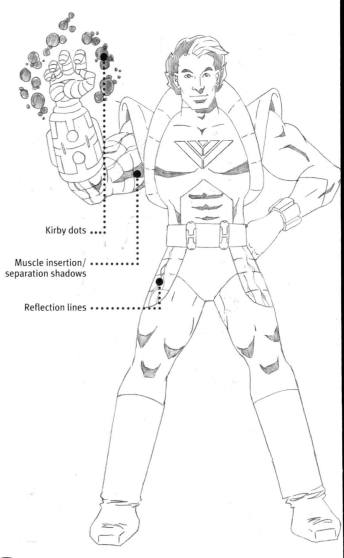

6 Erase the guidelines and check your drawing to see if the figure's basic construction is correct. If there are any problems with proportion, stance or general appearance, this is the time to correct them.

Kirby dots ·····

Muscle insertion/ ·········
separation shadows

Reflection lines ·········

7 Add the chest symbol to his costume and lightly draw in seams on his body armor. Indicate the fold of the boots above the ankle. Sketch a few hairs on the white section of his hair.

8 Fill in the shadows, including the ones indicating muscles. These dark areas show where major muscle groups either insert or separate (as in the case of the deltoid and the bicep) and add depth to your drawing. Indicate the reflective surface of the armor with thin, squiggly lines. Finally, add a series of Kirby dots (see page 56) around the gauntlet to represent a nimbus of energy.

INKING BASICS

Most inking is done with either a marker-type pen or a brush (sometimes a combination of the two), depending on which tool the artist is most comfortable using. So long as the ink is jet black and waterproof (assuming you're going to hand-color as opposed to using computer coloring), either tool is fine.

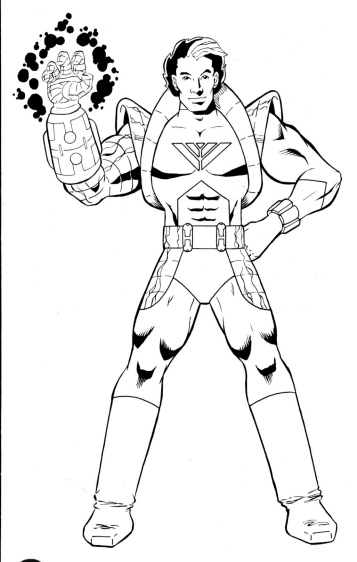

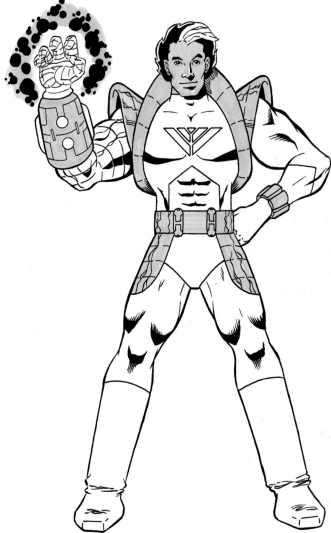

9 Notice how the contour lines of the Millennium Knight get thicker around the larger muscles, like the biceps or the quadriceps. An ultra-fine tip permanent marker will work for this and the seams of the armor, the chest logo and the borderlines of his glove, boots and tights. After the ink is dry, erase any remaining pencil lines.

10 Using a brush-tip marker, add the lightest colors first. That will usually be the yellows and flesh tones. Carefully color each area with its respective color using even, parallel strokes. Continue adding colors, working from light to dark.

Random Strokes Parallel-Line Strokes

Parallel-Line Strokes Work Best for Markers
Markers always cause a certain amount of streaking. Even, parallel-line strokes give you the smoothest look and minimize that streaking.

For the Millennium Knight I used a sable-haired, no. 1 watercolor brush and waterproof, black India-density ink (that just means it's really, really black ink). I used the brush because it allowed me to vary the line thickness. I used a no. 1 width (.05 mm) technical pen for the armor seams and borderlines.

Super Strength

Next to flight, the ability to heave tonnage around is the most commonly possessed power. This pose is just one way to show your hero using his super strength.

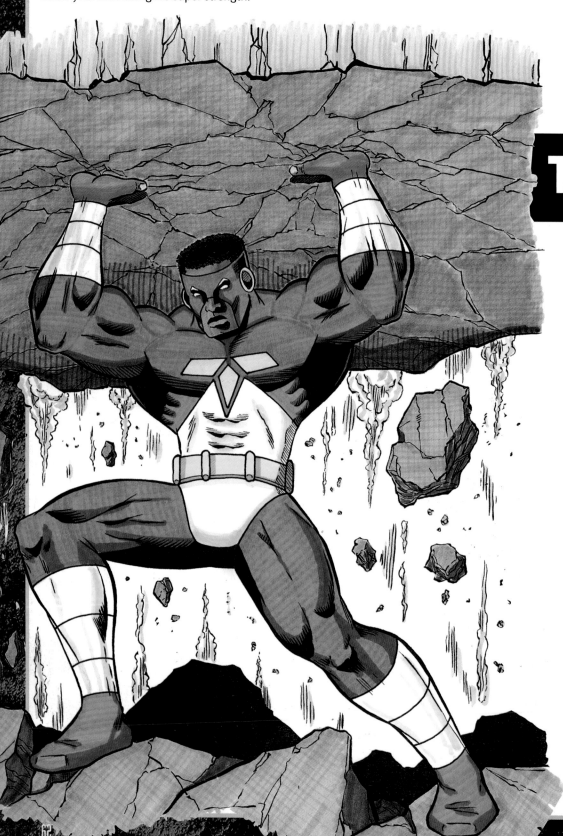

TORQUE

Magna City's strongest hero, Torque, has the ability to increase his size and density a thousand-fold. At top strength, he's ten feet tall, can lift seventy tons and stand up to a bazooka blast unharmed.

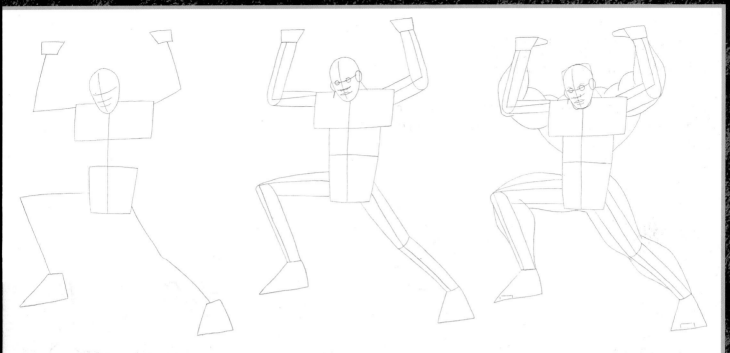

1 As always, start by lightly sketching in a basic skeletal structure. As Torque strains to lift the intense weight, his chin dips downward and the arms and shoulders push up, partially obscuring the center line of his neck. His legs are bent and in a wide stance for stability.

2 Add tubing and indicate Torque's facial features. Sketch in the outer contours of his neck. He's a giant-sized hero, so his neck will be wider than a person of normal proportions.

3 Surround the tubing with extra large and thick musculature. Detail the contours of his face and hair, then give him eyebrows and a lower lip. Indicate his thumbs and the toe box.

4 A good strength pose shows every muscle bulging and rippling. Refer to the muscle chart on page 32. Add fingers and refine the shape of his feet. Lightly sketch in the mask and belt. Indicate the general shape of the massive, sixty-ton stone he's lifting.

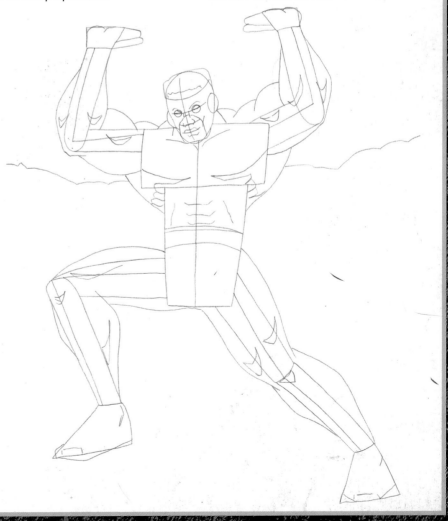

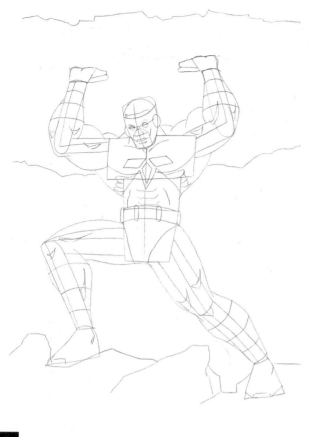

5 Add detail to his costume, such as the wrist and ankle rings, the belt capsules, the tights and the chest symbol. Indicate the upturned rocks on the ground.

6 Erase the guidelines and darken the remaining pencils. Check your drawing for any basic errors in face or body construction and fix them. Detail the stone and add stress fractures radiating out from under his hands. Add some falling rocks and soot for a sense of movement.

7 Darken the shadows and muscles. Detail all the rocks with fracture lines. Add hatch lines to the body to increase the feeling of rippling muscularity.

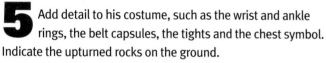

Hatch lines are a series of short straight, parallel lines. Their effect is sometimes referred to as *feathering*.

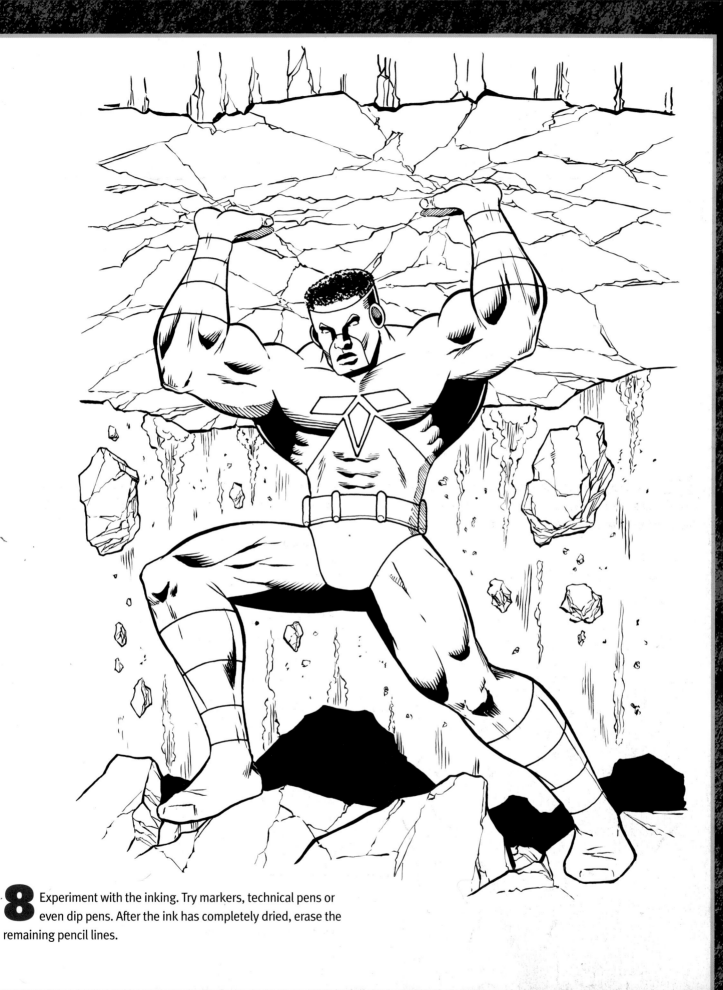

8 Experiment with the inking. Try markers, technical pens or even dip pens. After the ink has completely dried, erase the remaining pencil lines.

Heroes on the Move

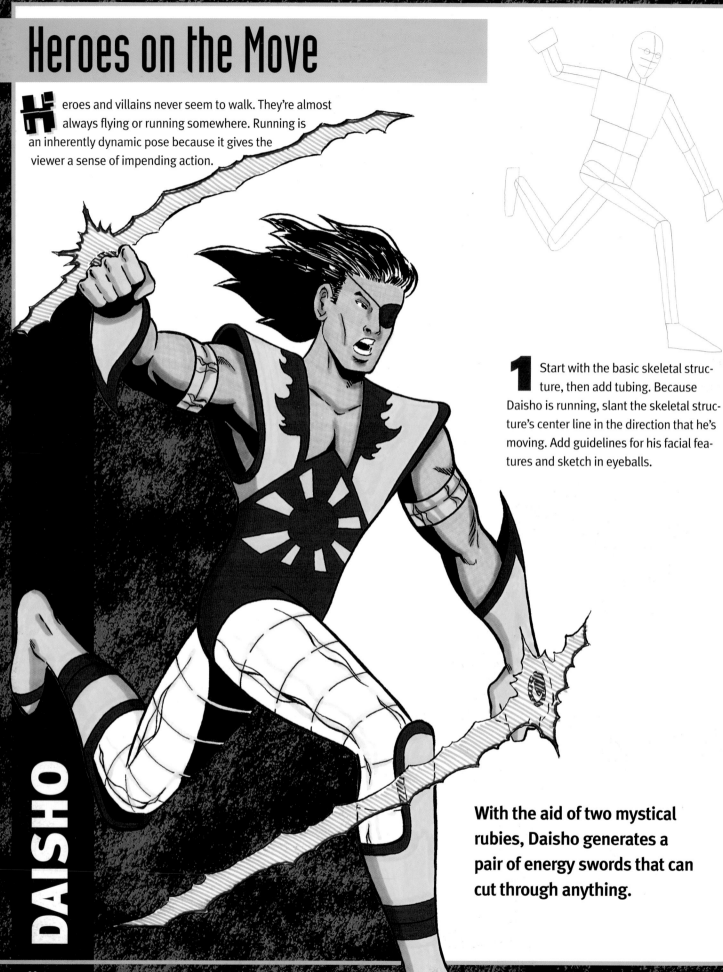

eroes and villains never seem to walk. They're almost always flying or running somewhere. Running is an inherently dynamic pose because it gives the viewer a sense of impending action.

1 Start with the basic skeletal structure, then add tubing. Because Daisho is running, slant the skeletal structure's center line in the direction that he's moving. Add guidelines for his facial features and sketch in eyeballs.

With the aid of two mystical rubies, Daisho generates a pair of energy swords that can cut through anything.

DAISHO

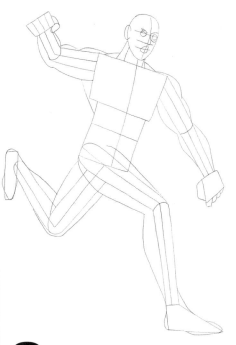

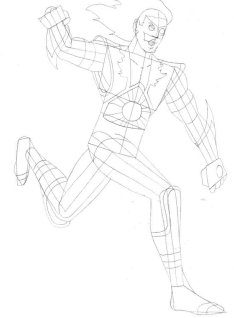

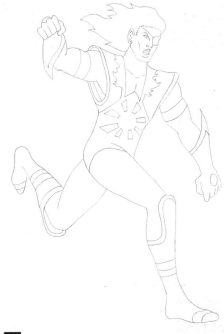

2 Surround the tubing with musculature, then begin to detail his eyebrows, nose, mouth and ear. Add thumbs and indicate fingers.

3 Make his hair long and flowing to add movement. Detail the shape of his right eyelid and add an eye patch to his left. Sketch the outer wings of his nostrils, add teeth, indicate his lower lip, and detail his inner ear. Begin some of the costume's details. Refine the flame and rising sun designs on his chest and torso.

4 Erase the guidelines and fix any problems in basic construction. Then darken the remaining art.

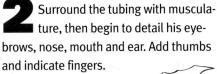

COLOR TIPS

Add color starting with the flesh tones and yellows again. Add hatch lines using the fine-tip end of a yellow marker to make the energy swords look more transparent.

5 Add shadows. Indicate the seams and reflective lines on Daisho's body armor. Sketch in the energy swords. Ink over your pencil drawing once you're happy with it. Leave the outline of the swords unconnected and slightly varied in thickness for a lighter, more energized look.

Flying Heroes

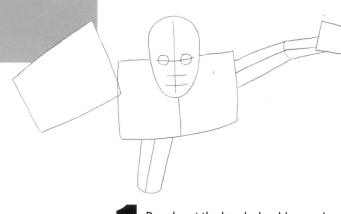

Flying can be portrayed as passive or active, depending on the pose. In this aerial action shot, extreme foreshortening creates the illusion that the hero is ready to burst off the page.

1 Rough out the head, shoulders and right fist. Since the fist is at the front of the scene (closest to you, foreshortening the arm), it appears larger than normal. Draw guidelines for the facial features, then add the eyeballs. Add tubing to the left arm and right knee.

From his fortress in the clouds, Vanguard defends the skies of the world at hypersonic speeds.

VANGUARD

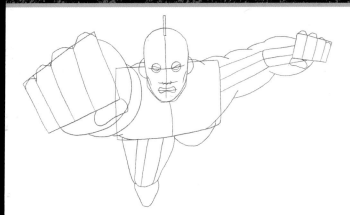

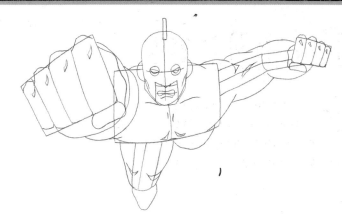

2 Draw Vanguard's foreshortened right arm and facial features. Surround the structure with musculature, then indicate his upper left thigh and fingers.

Sketch in his ear cups and head fin. Refine the contours of his jawline and cheekbones. Indicate the ends of his thumbs and knuckles, then add his right foot.

3 Refine his fist contours. Rough in his muscles and indicate the mouth opening of the 3/4 mask.

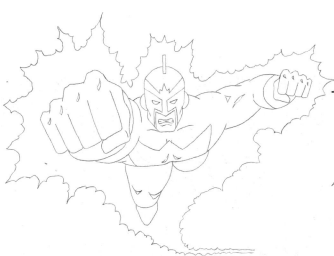

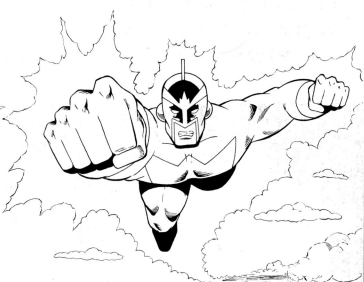

4 Erase the guidelines and fix any structural or compositional errors. Detail the costume, including the trim around the mask, the gloves and the chest symbol. Surround him with a crackling field of energy that trails off into the distance.

5 Shadows can create the illusion of distance by creating contrast between the foreground and the background. The shadows on Vanguard's right foot and left thigh enhance the feeling of depth. The small clouds in the background increase the feeling of distance, too.

As you ink your drawing, try a thin, unconnected brush line to indicate both the fluffiness of clouds and the crackle of energy. Wait for the ink to fully dry before erasing the remaining pencil lines.

COLOR TIPS

In comics, energy rays and fields are represented by any number of hues (purple for Star Sapphire, green for Green Lantern, even black for Shadow Lass and Obsidian), but yellow is the most common color. Likewise, light blue is the color most used for highlighting sky and clouds.

Flying Heroines

Passive portrayals of flying are generally reserved for moments of calm, where the hero or heroine is peacefully floating skyward. That, however, doesn't mean your picture has to be boring. Sometimes shifting the point of view can make an ordinary pose more dynamic. By lowering our vantage point and looking up at Blue Skye (a worm's-eye view, page 121), a greater sense of drama is injected into a standard side view.

1 Sketch the skeletal structure and feature guidelines. Play around with your hero flying positions. Arms don't always have to be front and legs don't always have to be straight back.

Empowered by meson rays, physicist Lana Skye uses her new-found powers of flight and invulnerability to battle evil as Blue Skye.

BLUE SKYE

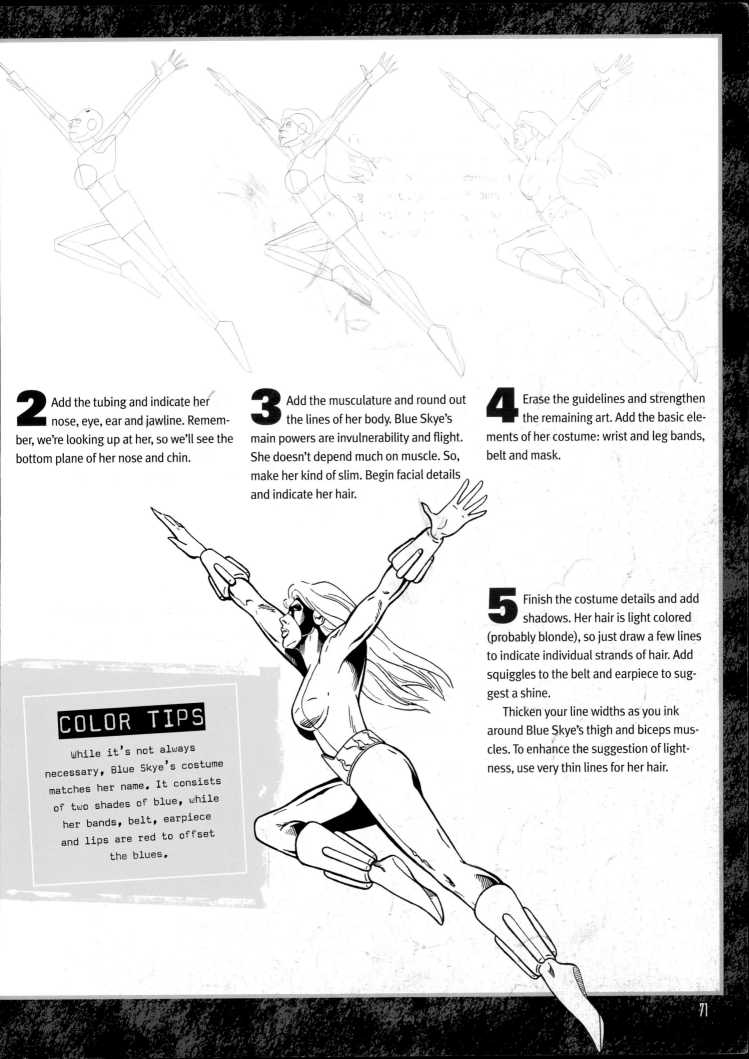

2 Add the tubing and indicate her nose, eye, ear and jawline. Remember, we're looking up at her, so we'll see the bottom plane of her nose and chin.

3 Add the musculature and round out the lines of her body. Blue Skye's main powers are invulnerability and flight. She doesn't depend much on muscle. So, make her kind of slim. Begin facial details and indicate her hair.

4 Erase the guidelines and strengthen the remaining art. Add the basic elements of her costume: wrist and leg bands, belt and mask.

5 Finish the costume details and add shadows. Her hair is light colored (probably blonde), so just draw a few lines to indicate individual strands of hair. Add squiggles to the belt and earpiece to suggest a shine.

Thicken your line widths as you ink around Blue Skye's thigh and biceps muscles. To enhance the suggestion of lightness, use very thin lines for her hair.

COLOR TIPS

While it's not always necessary, Blue Skye's costume matches her name. It consists of two shades of blue, while her bands, belt, earpiece and lips are red to offset the blues.

Non-Destructive Powers

Not all powers are destructive. Flight and enhanced vision powers, such as telescopic and x-ray vision, are passive in nature, but still powerful.

1 Shango is at a slight 3/4 angle and is rising up from below us. A slight amount of foreshortening is necessary because sections of Shango's body are partially hidden. His head hides the upper part of his neck, his lower torso is obscured by his chest, and his right thigh overlaps the lower half of his leg. Draw these overlapping body parts slightly smaller than normal.

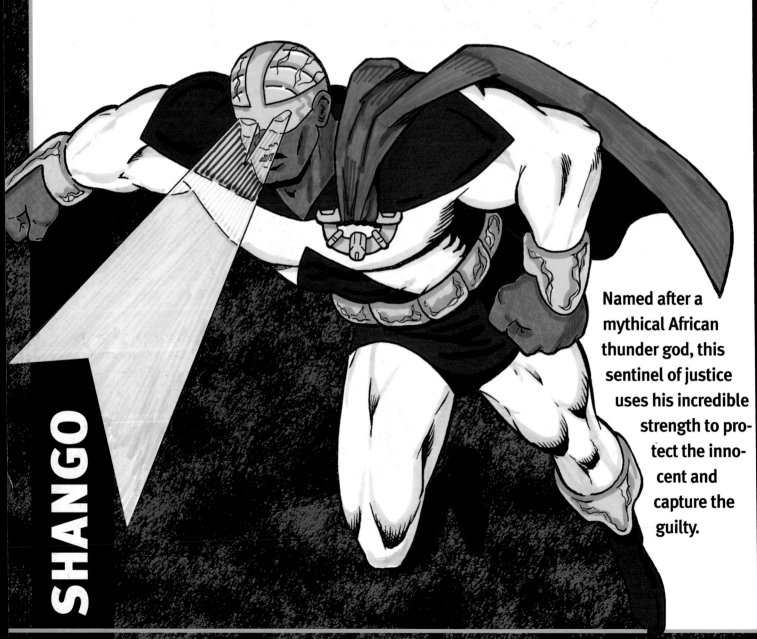

Named after a mythical African thunder god, this sentinel of justice uses his incredible strength to protect the innocent and capture the guilty.

SHANGO

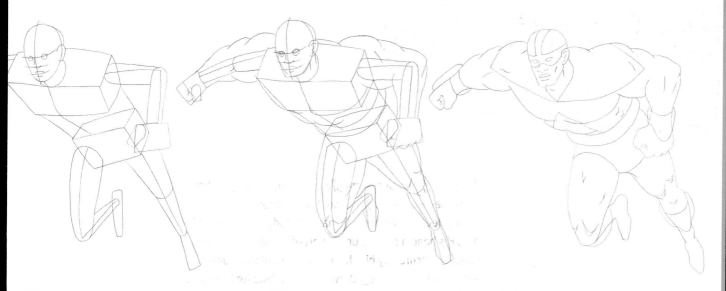

2 Fill out the figure with tubing and indicate the placement of his facial features. Draw his feet slightly smaller than normal to show the foreshortening. Indicate his thumbs.

3 Give Shango large muscles, especially on his arms and upper body to show his vast physical strength. Detail his facial features and fine tune the contours of his feet and fists.

4 Erase the guidelines and darken the remaining drawing. Begin to sketch in the details of his costume. Curve the outer edges of his wrist, belt and leg bands to show depth.

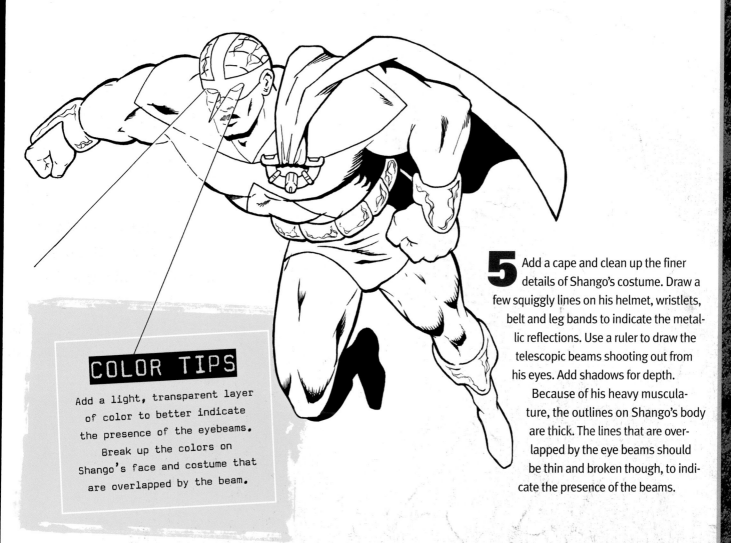

COLOR TIPS

Add a light, transparent layer of color to better indicate the presence of the eyebeams. Break up the colors on Shango's face and costume that are overlapped by the beam.

5 Add a cape and clean up the finer details of Shango's costume. Draw a few squiggly lines on his helmet, wristlets, belt and leg bands to indicate the metallic reflections. Use a ruler to draw the telescopic beams shooting out from his eyes. Add shadows for depth.

Because of his heavy musculature, the outlines on Shango's body are thick. The lines that are overlapped by the eye beams should be thin and broken though, to indicate the presence of the beams.

Fighting Heroes

An authentic-looking fighting stance is essential when drawing martial arts-type heroes. Study karate and kung-fu magazines for good, economical visual references and information. The flying kick is often drawn because it's an exciting pose with a lot of suggested movement.

1 As always, start with the basic structure, indicating the center lines and the joints.

DRAGON

Trained by the last of the Great Dragons in the secret art of Xing-Qi, this martial arts master possesses unmatched speed and stamina. His fists are stronger than steel and his Thunder Kick can stop a tank in its tracks.

2 Add tubing to the basic structure and draw guidelines for the facial features. The neck is slightly foreshortened because the upraised arms and lowered head partially block our view of it.

3 Because Dragon is known for his speed and agility, his muscles shouldn't be too large or heavy. His body, especially his abs, should be well defined. Indicate his thumbs and refine the contours of his feet. Add detail to his facial features and sketch his hair flying back to show movement.

4 Erase the guidelines and darken the remaining outlines. Fine tune the details of his face his indicate his fingers. Rough in the design of his costume and mask.

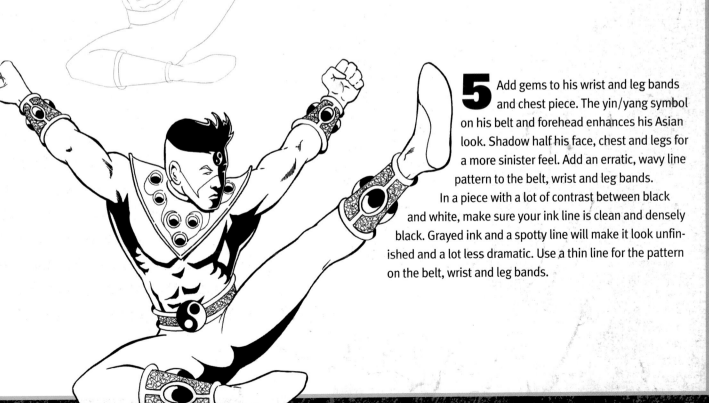

5 Add gems to his wrist and leg bands and chest piece. The yin/yang symbol on his belt and forehead enhances his Asian look. Shadow half his face, chest and legs for a more sinister feel. Add an erratic, wavy line pattern to the belt, wrist and leg bands.
In a piece with a lot of contrast between black and white, make sure your ink line is clean and densely black. Grayed ink and a spotty line will make it look unfinished and a lot less dramatic. Use a thin line for the pattern on the belt, wrist and leg bands.

DRAWING MOTION

In general, motion is shown in comics by a few lines behind the moving object, referred to as *motion* or *speed lines*. Sometimes they're used in conjunction with other lines representing the object's *after-image* (the image that sometimes remains after the object has already passed).

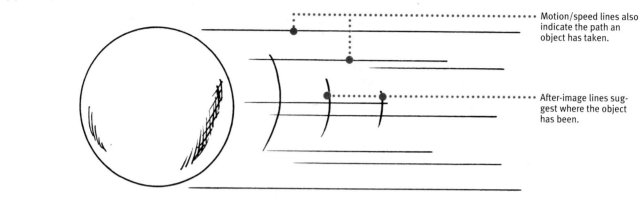

Motion/speed lines also indicate the path an object has taken.

After-image lines suggest where the object has been.

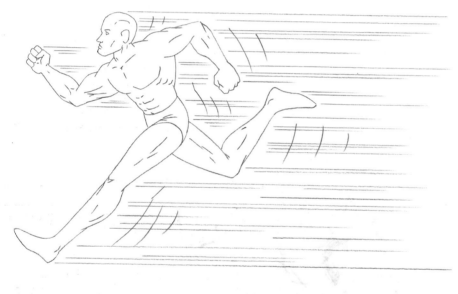

Speed Lines
Increase the number of motion and after-image lines as your hero increases speed. The more lines you use, the faster the movement.

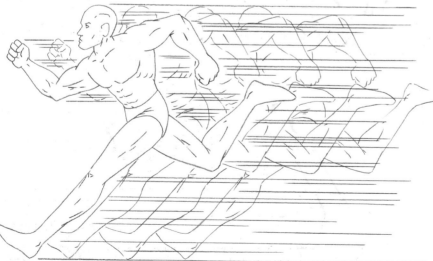

Multiple After-Images
Adding a series of after-images within the motion lines gives the impression that he's moving faster than our eyes can keep up with.

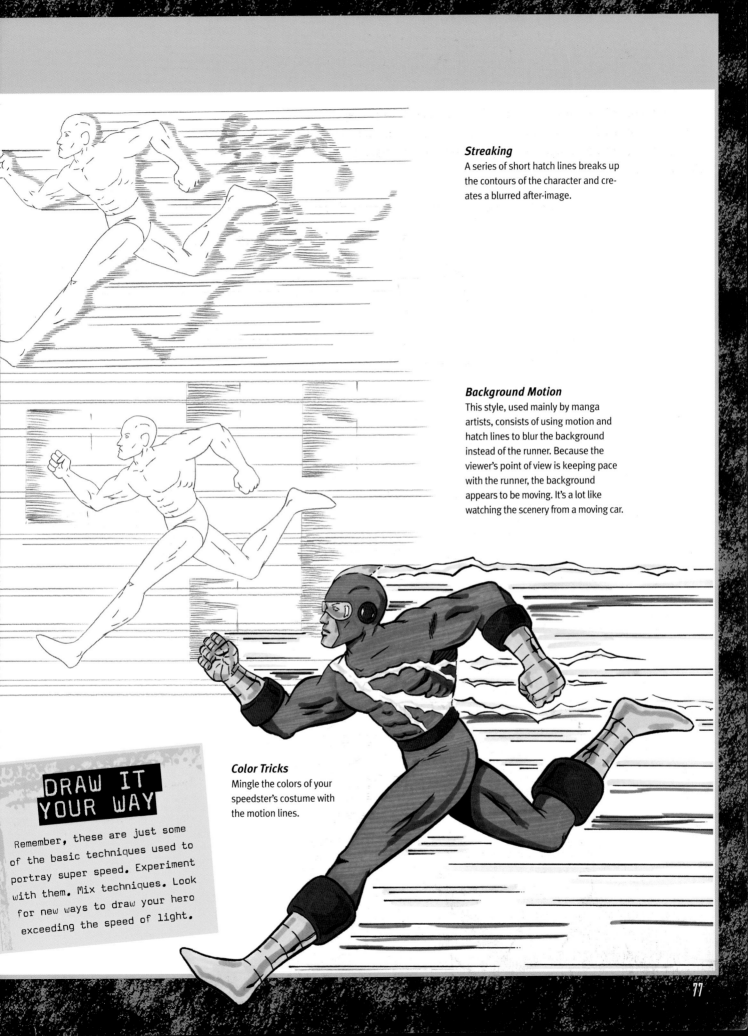

Streaking

A series of short hatch lines breaks up the contours of the character and creates a blurred after-image.

Background Motion

This style, used mainly by manga artists, consists of using motion and hatch lines to blur the background instead of the runner. Because the viewer's point of view is keeping pace with the runner, the background appears to be moving. It's a lot like watching the scenery from a moving car.

Color Tricks

Mingle the colors of your speedster's costume with the motion lines.

DRAW IT YOUR WAY

Remember, these are just some of the basic techniques used to portray super speed. Experiment with them. Mix techniques. Look for new ways to draw your hero exceeding the speed of light.

CREATING FIRE

Whether it's caused by heat vision or a book of matches, a good blaze should appear active and constantly moving. It should dance like it has a mind of its own. While you can't create actual movement on a single sheet of paper, you can duplicate it realistically.

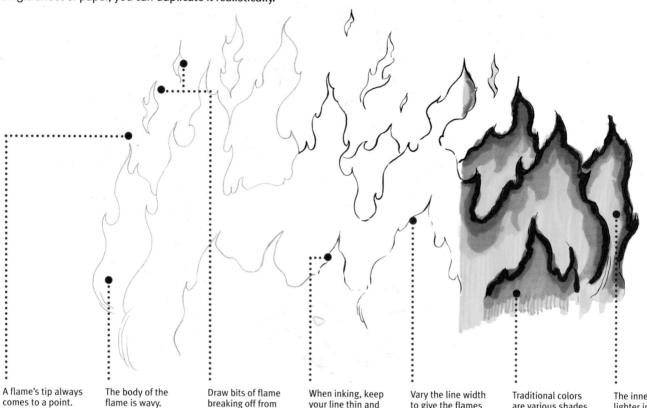

A flame's tip always comes to a point.

The body of the flame is wavy.

Draw bits of flame breaking off from the main body to show movement.

When inking, keep your line thin and unconnected in some areas to show the flame's instability.

Vary the line width to give the flames an organic look.

Traditional colors are various shades of yellow, orange and red.

The inner cone is lighter in color, while the outer edges become darker.

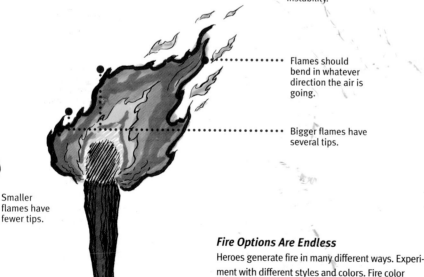

Flames should bend in whatever direction the air is going.

Bigger flames have several tips.

Smaller flames have fewer tips.

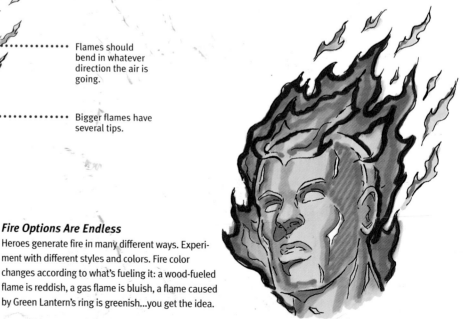

Fire Options Are Endless

Heroes generate fire in many different ways. Experiment with different styles and colors. Fire color changes according to what's fueling it: a wood-fueled flame is reddish, a gas flame is bluish, a flame caused by Green Lantern's ring is greenish...you get the idea.

DRAWING EXPLOSIONS

Explosions and superheroes go together like ice cream and cake. It's hard to have one without the other. Sometimes explosions are caused by a bomb and sometimes they're caused by the eye beams of a mutant hero. A good explosion packs a dramatic punch. It adds excitement to a drawing. It should look dangerous, destructive and, well, explosive.

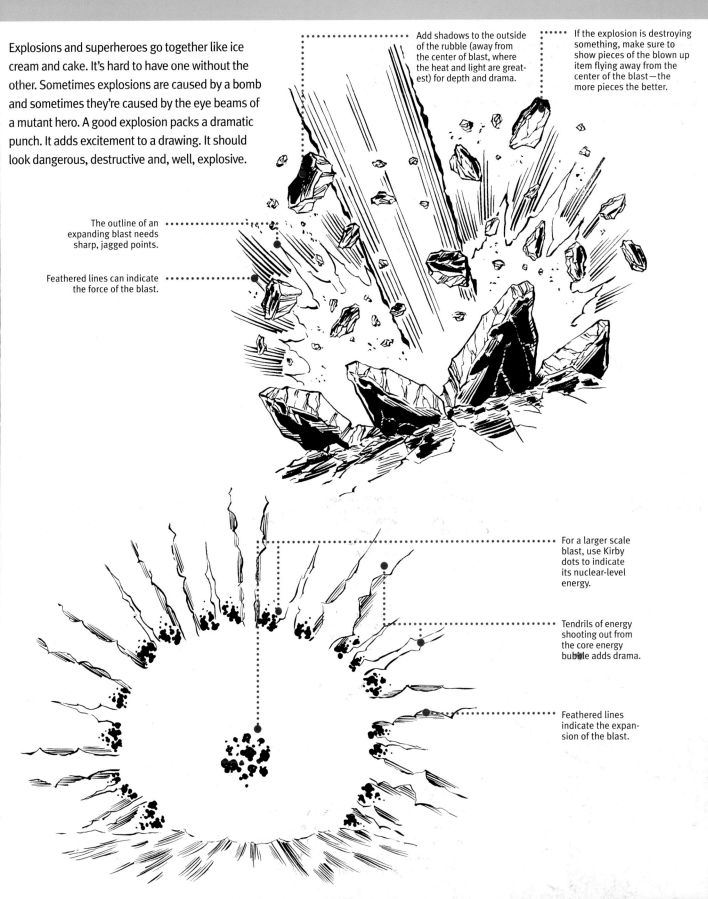

Add shadows to the outside of the rubble (away from the center of blast, where the heat and light are greatest) for depth and drama.

If the explosion is destroying something, make sure to show pieces of the blown up item flying away from the center of the blast—the more pieces the better.

The outline of an expanding blast needs sharp, jagged points.

Feathered lines can indicate the force of the blast.

For a larger scale blast, use Kirby dots to indicate its nuclear-level energy.

Tendrils of energy shooting out from the core energy bubble adds drama.

Feathered lines indicate the expansion of the blast.

Super Speed

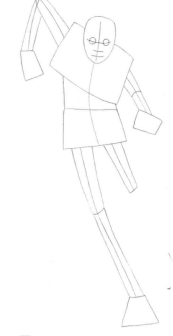

s Quicksilver quicker than Impulse? Does the Whizzer run faster than Jonni Quick? Can Superman out-sprint the Flash? No matter who's got the greater horsepower, they're all moving much faster than everyone around them. As a result, the art has to somehow indicate their enormous speed. This running pose makes use of motion and after-image lines to convey the impression of great speed.

1 Sketch the skeletal structure and surround it with tubing. Velocity's left arm and fist are angled towards us, so they'll be foreshortened slightly. Indicate the placement of the facial features and add the eyeballs.

The world is a still-life painting to the fastest man on Earth. Able to travel the globe in a matter of seconds, Velocity stops evil in its tracks.

VELOCITY

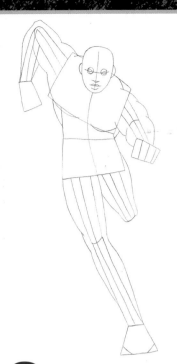

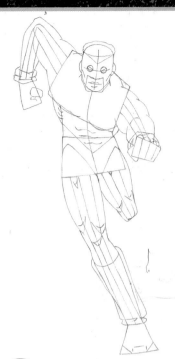

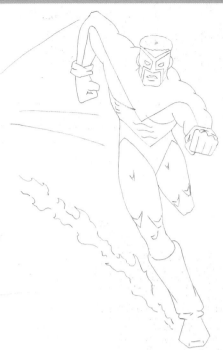

2 Fill out the figure with the outer contours of the musculature. Indicate the fingers, then the contours of his foot. Begin to detail his facial features.

3 Fill in his body's interior muscles. Add thumbs, knuckles and the toe box. Refine the shape of his jawline and indicate the contours of his hair. Rough in the costume elements and add some folds to the fabric at his wrists and ankle.

4 Erase the unnecessary guidelines and make sure all the proportions and contour lines are correct. Detail the trim on his face mask and body suit. Add some motion lines and the indication of flame at Velocity's feet to show how his speed is burning up the ground.

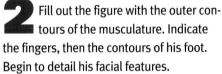

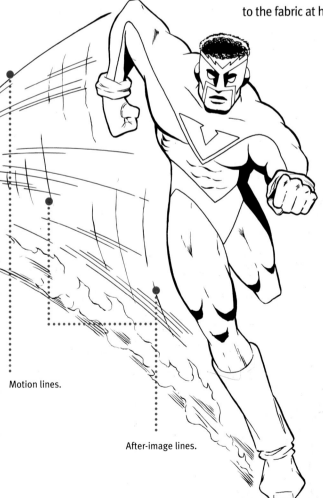

5 Darken the shadows around his muscles. Add the "V" chest symbol and more motion and after-image lines.

To ink extremely curly hair, hold a pen or brush tip vertically above the paper and lightly dab it repeatedly. This will create a rough texture.

Motion lines.

After-image lines.

Heat Vision

During the Golden Age of comics, heat vision was drawn as a simple pair of straight, red-colored lines coming from the eyes. Today's artists use more flair in their portrayal of such powers.

A living nuclear reactor, Neutron can unleash a destructive blast of atomic fire from his eyes.

1 Lightly sketch his skeletal structure. Because his head is in a 3/4 view, we can see the bulge of the occipital/parietal bone on the back of the head. Add guidelines for his facial features and rough in the eyeballs.

NEUTRON

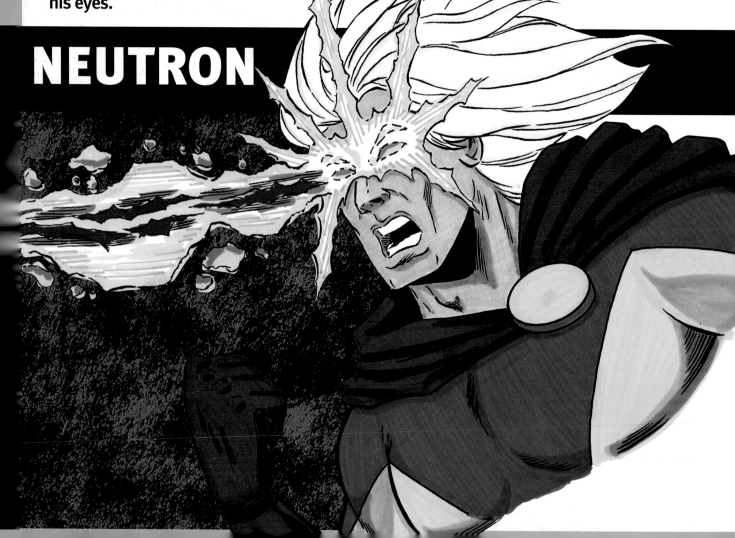

2 Add tubing and refine the shape of his face and jawline, then indicate the facial features. Give Neutron a wider than normal neck and large trapezius muscles (see muscle chart on page 32). Sketch the contours of his hair, giving it a long, blown-back look for dramatic effect. Indicate his fingers.

3 Add detail to his eyelids, nostrils and mouth. Refine his little finger and add a thumb. Sketch in the costume's chest design and add the cape. Indicate a nuclear flash around his eyes and a blast of atomic fire.

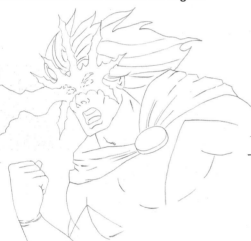

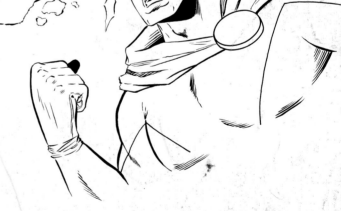

4 Erase the guidelines and fix any construction mistakes. Break up the lines of his eyes and brows to indicate the intense energy coming from them. Lightly draw a few strands of hair, then add some folds to his cape and gloved wrist.

COLOR TIPS

Use the fine-tip ends of yellow and orange markers to give the atomic blast a more dramatic look.

5 Darken the shadows. Fine tune his knuckles and add a seam to indicate the glove. Add some hatch lines to bring out the musculature. Draw a few stray energy balloons to give more strength to the atomic blast.

After you've inked your drawing and the ink has completely dried, erase any remaining pencil marks. A broken ink line of varied thickness will enhance the look of the energy blast.

Energy Powers

Whether your hero has been cosmically-endowed like Captain Mar-Vell, is a human nuclear reactor like Captain Atom, or simply has the ability to absorb and emit solar radiation like Sunburst here, the power to wield energy is grand one. More often than not it's portrayed as the ability to emit bolts of power, usually from the hands or eyes.

In this picture, we're viewing Sunburst's flight from a slightly higher vantage point, known as a bird's-eye view (see page 121). A lower vantage point would be called a worm's-eye view.

COLOR TIPS

An extra splash of yellow within the light blue field of the energy blast creates a little more visual interest. Hatch marks using the fine-tip ends of both markers give the blast more texture.

SUNBURST

Imbued with the energy of the stars, this stellar-powered champion is able to manipulate all forms of electromagnetic radiation.

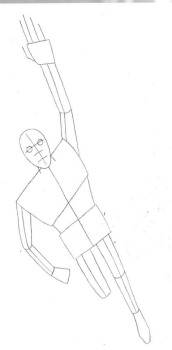

1 Draw the guidelines indicating his features, then draw his eyeballs. Surround the basic structure with tubing. In this pose the right leg is bent, hiding it from view.

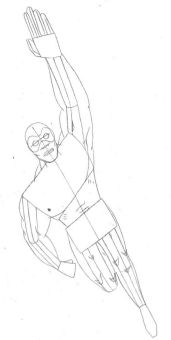

2 Refine the shape of his face and jaw-line. Add goggles and begin detailing the nose and mouth. Add the musculature. Indicate the fingers of his left hand and add the thumb to his right fist.

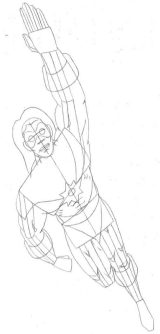

3 Add ears and the contours of his hair. Rough in his costume details: bands for the wrists, waist and leg, tights, and the chest symbol.

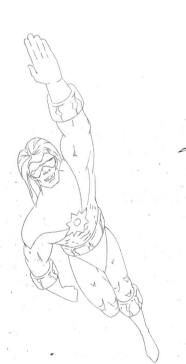

4 Erase the guidelines and check for any mistakes. Detail his inner ears and indicate strands of hair. Add some thin, squiggly lines to show the reflective goggles, wrist, belt and leg bands.

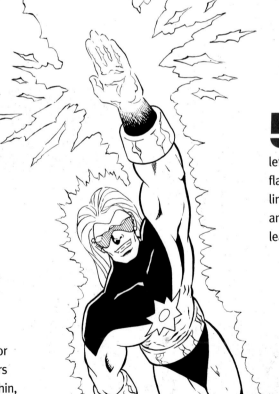

5 Darken the shadows and black areas of the costume, except for the left hand. Leave that white to show the flare of energy bursting forth. Add a crackling blast of energy shooting from his hand and surrounding his body in a nimbus that leaves a glimmering trail behind him.

Heroines With Firepower

Creating Midnight Blaze's cornrowed hair and headdress may seem like an unimportant detail, but when every hero (and villain) dresses in a colorful, skin-tight costume, it's the little things that make each character memorable and unique. This includes how you detail their powers, like Electro's lightning-style bolts, the sparkles that indicate Captain Mar-Vell's cosmic trail, or even Midnight Blaze's purple-colored blasts.

COLOR TIPS

Midnight Blaze, like other characters who are identified with the night (Batman and the Huntress, for example), looks better in darker tones and colors like dark blues, purples, grays and, of course, black. This makes her more mysterious and helps her fade into the darkness.

MIDNIGHT BLAZE

Wielding bolts of Stygian fire, Midnight Blaze draws on the power of the night to defend the innocent.

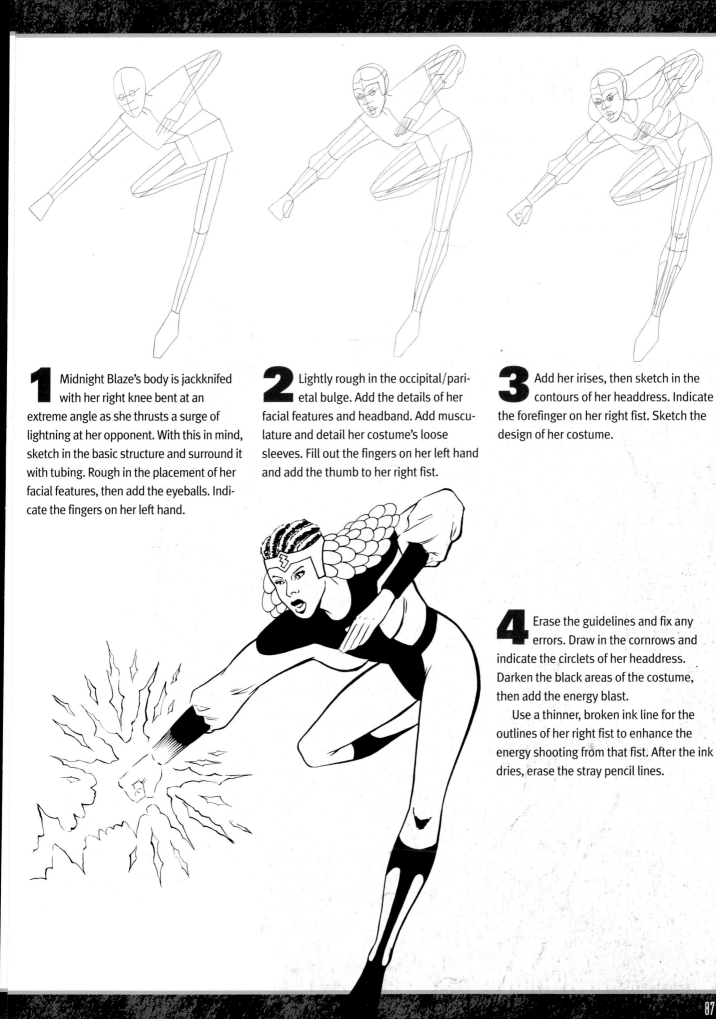

1 Midnight Blaze's body is jackknifed with her right knee bent at an extreme angle as she thrusts a surge of lightning at her opponent. With this in mind, sketch in the basic structure and surround it with tubing. Rough in the placement of her facial features, then add the eyeballs. Indicate the fingers on her left hand.

2 Lightly rough in the occipital/parietal bulge. Add the details of her facial features and headband. Add musculature and detail her costume's loose sleeves. Fill out the fingers on her left hand and add the thumb to her right fist.

3 Add her irises, then sketch in the contours of her headdress. Indicate the forefinger on her right fist. Sketch the design of her costume.

4 Erase the guidelines and fix any errors. Draw in the cornrows and indicate the circlets of her headdress. Darken the black areas of the costume, then add the energy blast.

Use a thinner, broken ink line for the outlines of her right fist to enhance the energy shooting from that fist. After the ink dries, erase the stray pencil lines.

Invulnerable Heroes

As powers go, invulnerability is a good one; after all, it's always nice to know you can't be physically harmed. But invulnerability is never total, since all heroes have at least one major weakness. Even the Aegis, like most physically indestructible heroes, can be affected mentally.

While foreshortening makes Aegis appear to be running out from the page at us, a barrage of weapons' fire shoots back into the scene. The weapons' fire not only adds another level of dimension and drama to the picture but also shows Aegis's super powers.

COLOR TIPS

Light blue highlights add texture to the white areas. Highlight black hair with a dark blue, like the color used in comics for Superman's hair.

AEGIS

With skin harder than diamonds, Aegis is immune to all forms of physical harm.

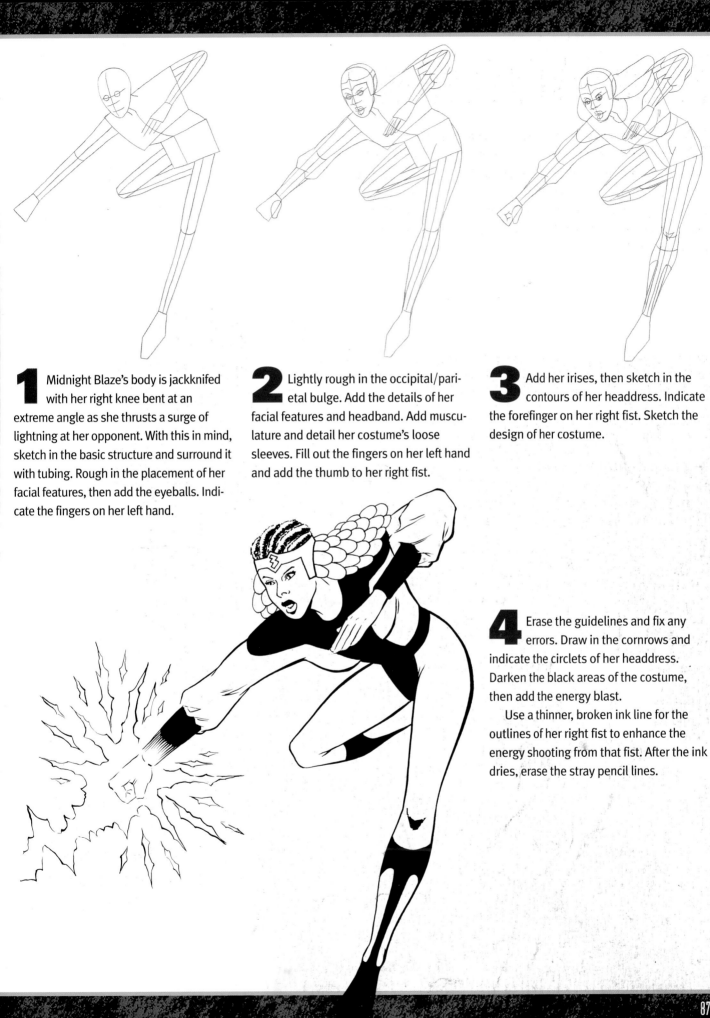

1 Midnight Blaze's body is jackknifed with her right knee bent at an extreme angle as she thrusts a surge of lightning at her opponent. With this in mind, sketch in the basic structure and surround it with tubing. Rough in the placement of her facial features, then add the eyeballs. Indicate the fingers on her left hand.

2 Lightly rough in the occipital/parietal bulge. Add the details of her facial features and headband. Add musculature and detail her costume's loose sleeves. Fill out the fingers on her left hand and add the thumb to her right fist.

3 Add her irises, then sketch in the contours of her headdress. Indicate the forefinger on her right fist. Sketch the design of her costume.

4 Erase the guidelines and fix any errors. Draw in the cornrows and indicate the circlets of her headdress. Darken the black areas of the costume, then add the energy blast.

Use a thinner, broken ink line for the outlines of her right fist to enhance the energy shooting from that fist. After the ink dries, erase the stray pencil lines.

Heroes From Other Planets

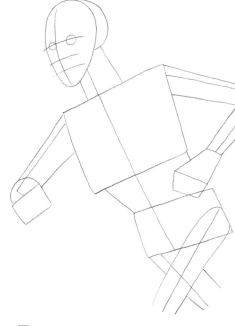

Sometimes Earth's best defenders, such as Superman, Captain Mar-Vell and the Martian Manhunter, come from other planets. But they're almost always drawn with comfortably human characteristics—two eyes, a nose and mouth, a pair of arms and legs. If you want your hero to appear more extra-terrestrial, yet still humanoid in appearance, add minor changes like a pair of pointy ears, different skin tone, tattoos or an energy-firing gem and an unusual hair style.

1 Draw the basics as usual. Because this is a 3/4 view, add the occipital/parietal bulge in the back of the skull. Surround the basic structure with tubing.

GEMFIRE

A former police officer from the planet A'ntean, Gemfire crash-landed on Earth. Now she defends her adopted world from extraterrestrial invasion.

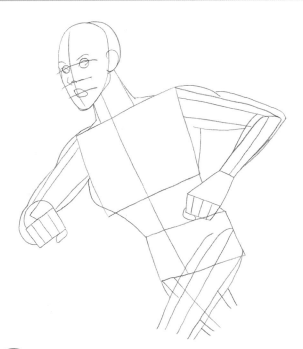

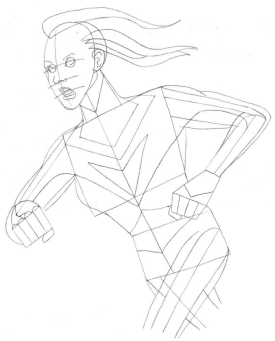

2 Rough in the facial features, then refine the face contours and jawline. Gemfire is a little bigger than the average superheroine, so give her a bit more muscle. Smooth out the contours of her body. Indicate her fingers and add thumbs.

3 Detail her facial features and begin the hair. Since Gemfire is an alien, we have more freedom. Her hair is sparse and a bit wilder than a human heroine's would be. Rough in the design elements of her costume.

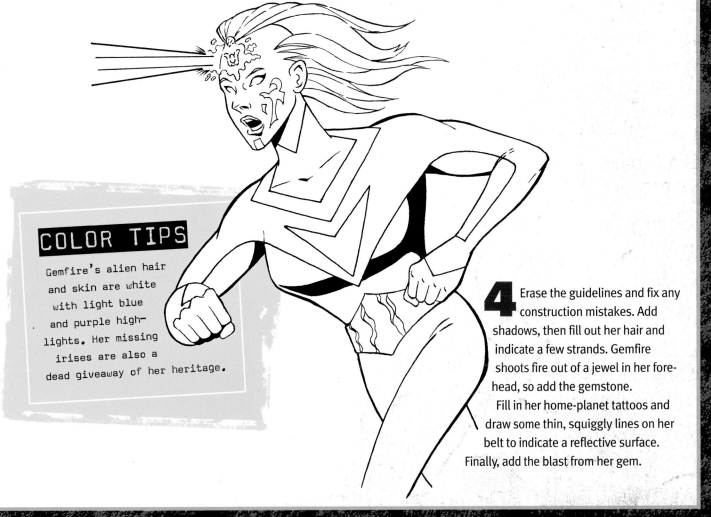

COLOR TIPS

Gemfire's alien hair and skin are white with light blue and purple highlights. Her missing irises are also a dead giveaway of her heritage.

4 Erase the guidelines and fix any construction mistakes. Add shadows, then fill out her hair and indicate a few strands. Gemfire shoots fire out of a jewel in her forehead, so add the gemstone.

Fill in her home-planet tattoos and draw some thin, squiggly lines on her belt to indicate a reflective surface. Finally, add the blast from her gem.

Invulnerable Heroes

As powers go, invulnerability is a good one; after all, it's always nice to know you can't be physically harmed. But invulnerability is never total, since all heroes have at least one major weakness. Even the Aegis, like most physically indestructible heroes, can be affected mentally.

While foreshortening makes Aegis appear to be running out from the page at us, a barrage of weapons' fire shoots back into the scene. The weapons' fire not only adds another level of dimension and drama to the picture but also shows Aegis's super powers.

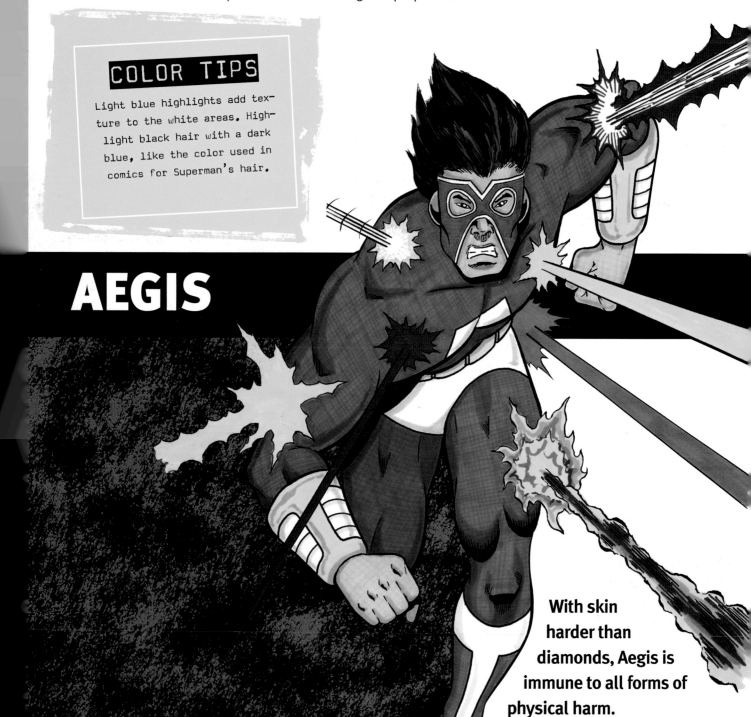

```
COLOR TIPS
Light blue highlights add tex-
ture to the white areas. High-
light black hair with a dark
blue, like the color used in
comics for Superman's hair.
```

AEGIS

With skin harder than diamonds, Aegis is immune to all forms of physical harm.

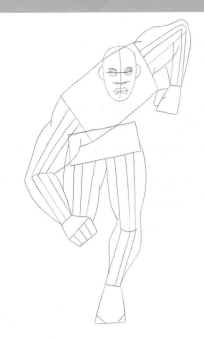

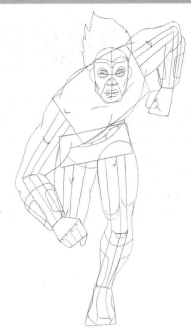

1 Because of the foreshortening, you should only see the top portion of Aegis's shoulders. Fill out the structure with tubing. Draw guidelines for his facial features and add his eyeballs.

2 Surround the tubing with basic musculature. Add eyelids, brows, nose and mouth to his face, then add ear cups. Indicate the fingers on his right hand and the thumb on his left. Begin the contour of his left foot.

3 Detail his jawline and sketch in the contours of his hair. Add his irises. Refine the interior muscles. Lightly sketch his wristbands and add the thumb to his right hand and the finger to his left fist. Fine tune the contours of his left foot and indicate the toe box. Rough in his costume.

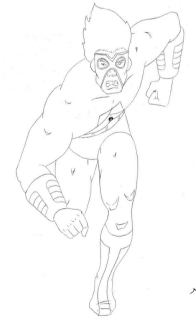

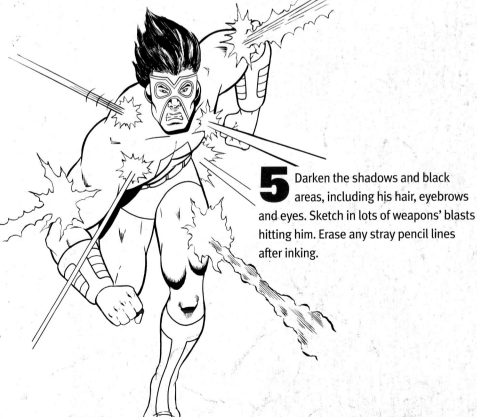

5 Darken the shadows and black areas, including his hair, eyebrows and eyes. Sketch in lots of weapons' blasts hitting him. Erase any stray pencil lines after inking.

4 Erase the guidelines and check for any proportion or pose mistakes. Refine his costume with details like the trim around his mask and the detail on his wristbands.

Beyond the Skintight Costume

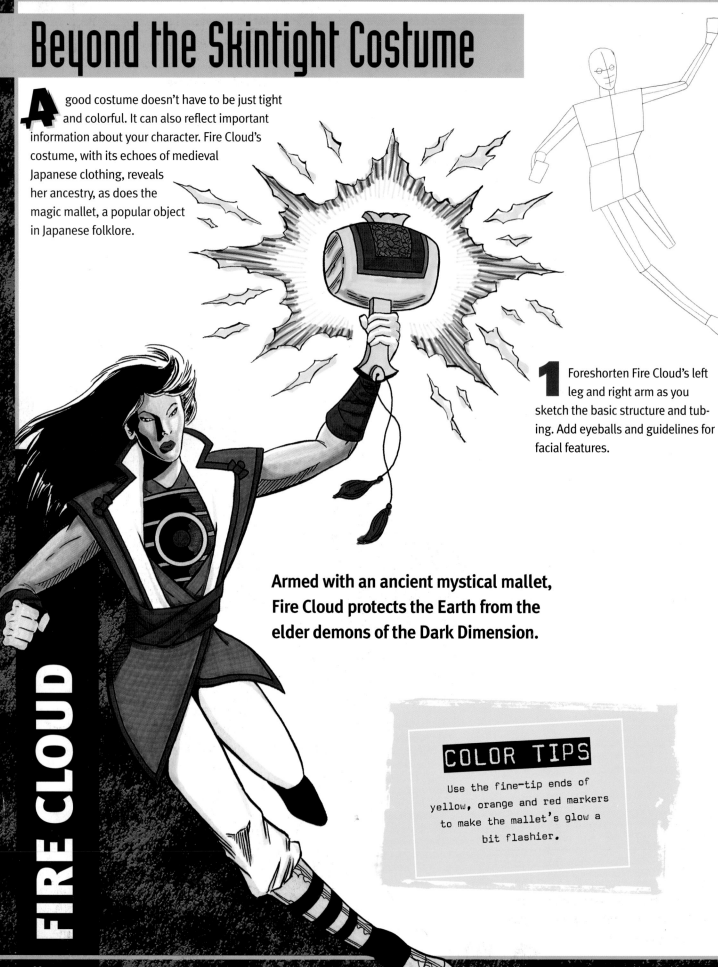

A good costume doesn't have to be just tight and colorful. It can also reflect important information about your character. Fire Cloud's costume, with its echoes of medieval Japanese clothing, reveals her ancestry, as does the magic mallet, a popular object in Japanese folklore.

1 Foreshorten Fire Cloud's left leg and right arm as you sketch the basic structure and tubing. Add eyeballs and guidelines for facial features.

Armed with an ancient mystical mallet, Fire Cloud protects the Earth from the elder demons of the Dark Dimension.

COLOR TIPS

Use the fine-tip ends of yellow, orange and red markers to make the mallet's glow a bit flashier.

FIRE CLOUD

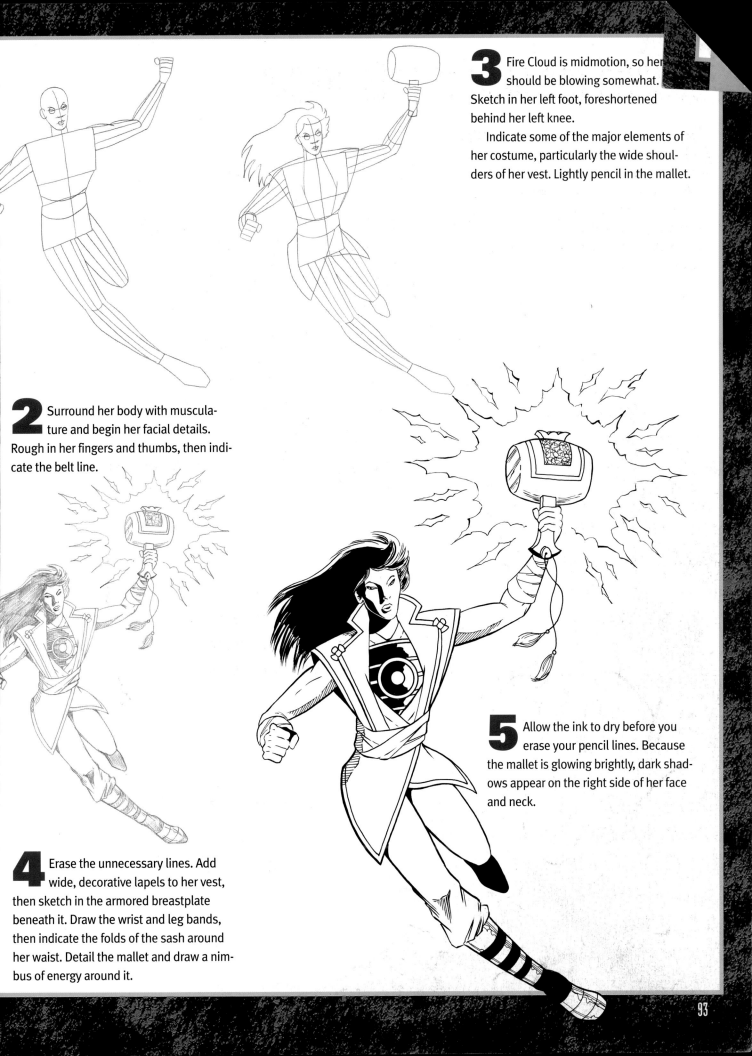

3 Fire Cloud is midmotion, so her [hair] should be blowing somewhat. Sketch in her left foot, foreshortened behind her left knee.

Indicate some of the major elements of her costume, particularly the wide shoulders of her vest. Lightly pencil in the mallet.

2 Surround her body with musculature and begin her facial details. Rough in her fingers and thumbs, then indicate the belt line.

5 Allow the ink to dry before you erase your pencil lines. Because the mallet is glowing brightly, dark shadows appear on the right side of her face and neck.

4 Erase the unnecessary lines. Add wide, decorative lapels to her vest, then sketch in the armored breastplate beneath it. Draw the wrist and leg bands, then indicate the folds of the sash around her waist. Detail the mallet and draw a nimbus of energy around it.

Modern Heroes With Ancient Weapons

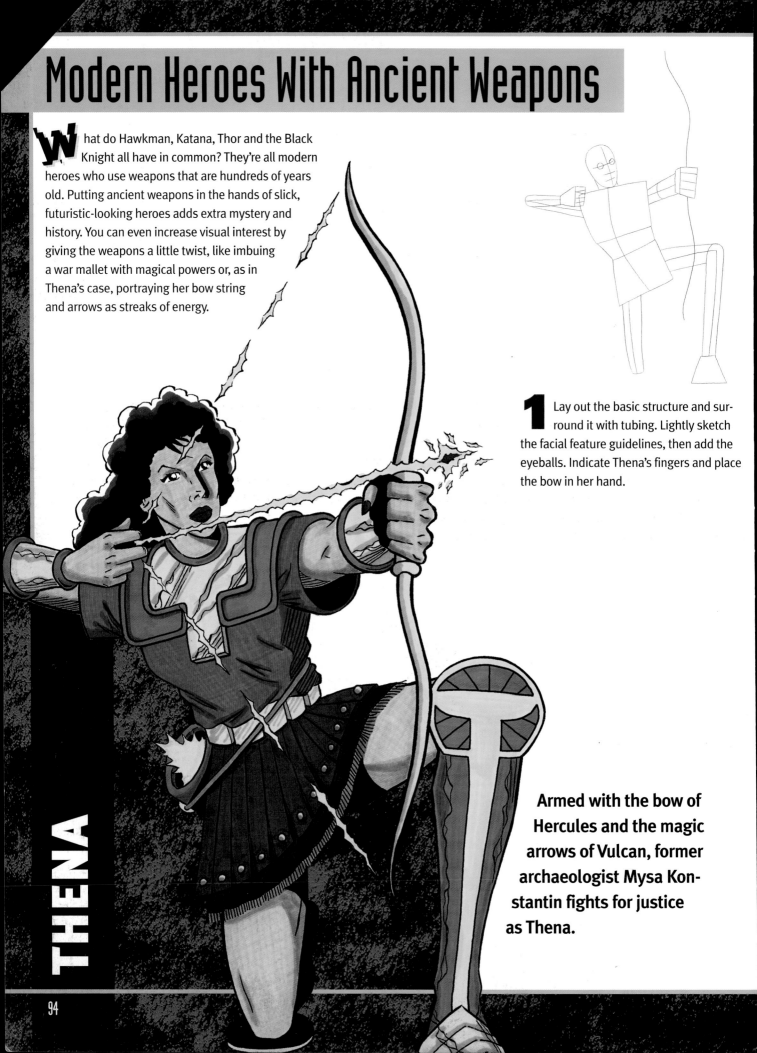

What do Hawkman, Katana, Thor and the Black Knight all have in common? They're all modern heroes who use weapons that are hundreds of years old. Putting ancient weapons in the hands of slick, futuristic-looking heroes adds extra mystery and history. You can even increase visual interest by giving the weapons a little twist, like imbuing a war mallet with magical powers or, as in Thena's case, portraying her bow string and arrows as streaks of energy.

1 Lay out the basic structure and surround it with tubing. Lightly sketch the facial feature guidelines, then add the eyeballs. Indicate Thena's fingers and place the bow in her hand.

THENA

Armed with the bow of Hercules and the magic arrows of Vulcan, former archaeologist Mysa Konstantin fights for justice as Thena.

94

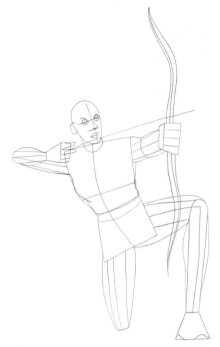

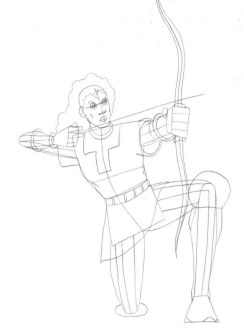

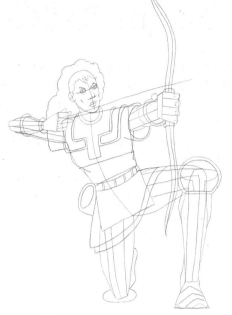

2 Add her facial features. Don't make the muscles too large. Since the right hand holds the bow string and arrow, extend the first two fingers to the second joint and indicate the arrow placement. Fill out the bow's body. Indicate some clothing folds around her waistline, add her belt and contour her left foot.

3 Rough in the contours of her hair, then refine the jawline. Add irises and thumbs. Lightly draw the sleeves on her blouse and the hem of her skirt. Indicate the collar, the "T" symbol on her chest, the armored wristbands and the shin guards. Detail her belt's individual plates.

4 Indicate the armor plating on her shoulders. Detail her knuckles. Add a small quiver to her right hip and a second skirt hem under the first one. Indicate her right foot behind the knee. Detail the seams and the "T" symbol on the shin guard.

5 Erase the guidelines and correct any proportion or pose mistakes. Detail the individual strips of leather and cloth on her outer and inner skirts. Add brass rivets to the ends of the leather strips and fringe to the ends of her inner skirt. Draw the quiver's strap and add an energy flash coming from the quiver itself. Darken the shadows and indicate the reflective armor.

Draw a thinner, slightly unconnected, line with slight width variations for the energy arrow and bow strings. Remember to let the ink dry before erasing your pencil lines.

The Antihero

The original superheroes of the 1940s and 1950s were flawless in their actions—courageous, idealistic and moral. By the 1980s a new, darker breed of costumed adventurer evolved: The Antihero. Antiheroes are unconcerned with notions of traditional good or evil. They are driven only by their own personal code of behavior.

Foreshortening can be used to create visual interest in a quiet scene, but it can also be used to pump up the drama in an action sequence. Like Vanguard (on page 68), Death Warrant's running pose is another example of how foreshortening can be used to create a dynamic sense of movement.

COLOR TIPS

In the world of comics, red, blue and yellow are basic color combinations (they are, after all, Superman's colors). Used here, they make Death Warrant hard to miss.

1 This pose uses extreme foreshortening to show Death Warrant in a bent-over run, so you'll only see the top of his shoulders and virtually none of his torso.

Draw the facial feature guidelines, then add eyeballs and ear cups. Add tubing and indicate the bottom plane of his right foot.

DEATH WARRANT

For a mere million dollars a day, this super-powered enforcer will work for anyone who can afford his fee.

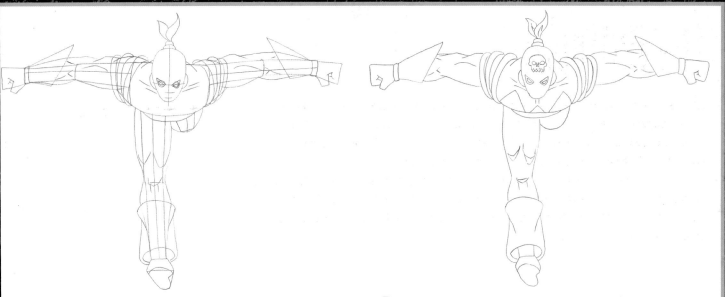

2 Surround the tubing with musculature. Begin the basic elements of his costume, such as the mask, shoulder rings, gloves and boot.

3 Erase the guidelines and correct any errors of proportion or pose. Strengthen the remaining drawing and add the skull on his forehead and his chest design.

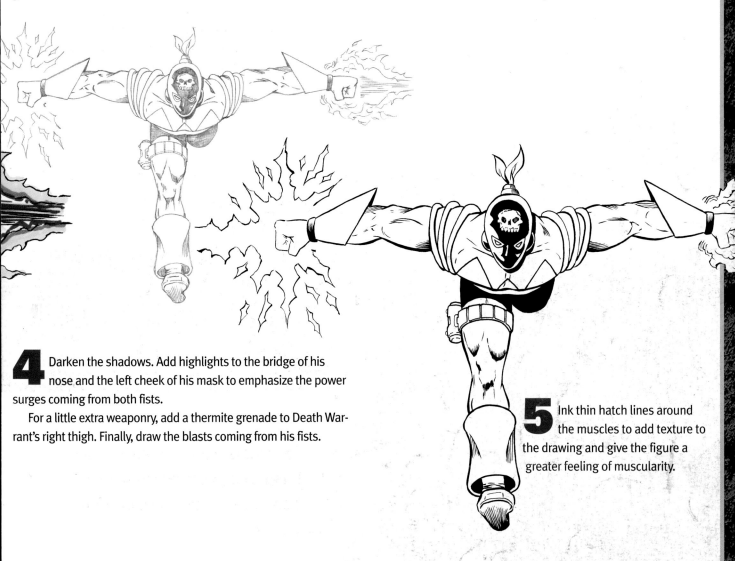

4 Darken the shadows. Add highlights to the bridge of his nose and the left cheek of his mask to emphasize the power surges coming from both fists.

For a little extra weaponry, add a thermite grenade to Death Warrant's right thigh. Finally, draw the blasts coming from his fists.

5 Ink thin hatch lines around the muscles to add texture to the drawing and give the figure a greater feeling of muscularity.

Super Gangsters

Powers only make a character "super"; how those powers are used is what makes a character a hero or a villain. Heroes are selfless, using their special abilities to help others, while villains use their powers solely for their own personal profit and pleasure. Whether it's Dr. Doom trying to take over the world or Mr. Scorch burning down buildings for the insurance money, it's not their powers that make them bad, but their purpose.

Remember that creating a sense of menace doesn't always require a monster with a big weapon and a flashy costume. Sometimes all it takes is a suit, a nonchalant pose, and a malicious grin.

1 Rough in the basic structure and surround it with tubing. Indicate the upraised finger of his right hand. Since his left hand is inside his pants pocket, simply indicate where the pocket opening will be and end the wrist there.

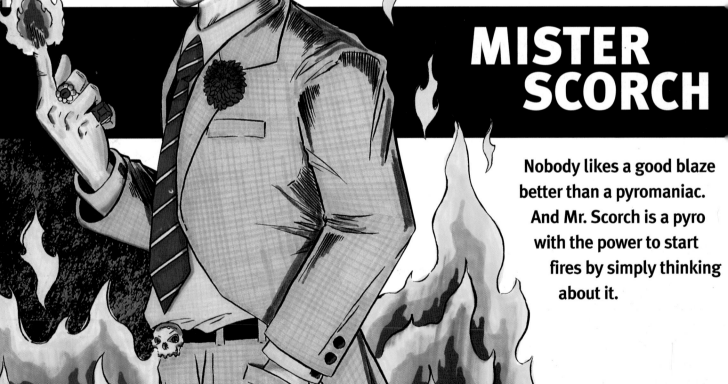

MISTER SCORCH

Nobody likes a good blaze better than a pyromaniac. And Mr. Scorch is a pyro with the power to start fires by simply thinking about it.

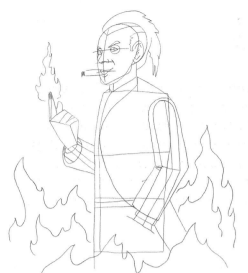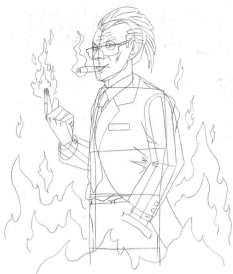

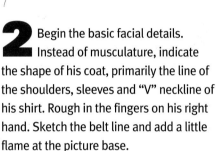

2 Begin the basic facial details. Instead of musculature, indicate the shape of his coat, primarily the line of the shoulders, sleeves and "V" neckline of his shirt. Rough in the fingers on his right hand. Sketch the belt line and add a little flame at the picture base.

3 Refine his face and jaw. Add a smirk to his mouth. Sketch his hair and place the cigar. Hatch lines at the tip of the cigar show the ash. Indicate the opening of his jacket and add shirt sleeves. Add his thumb and a few hatch lines to the tip of his finger for the heat of the flame around it. Increase the size of the blaze that surrounds him.

4 Give him some sunglasses and place a few wrinkles on his forehead to show age. Add a collar and tie to his shirt, then draw in his coat lapels and pocket. Add some folds to the coat, especially around the shoulders and under the arm. Place a few buttons and cuff links on the sleeves. Sketch the folds of his shirt above the belt line and indicate the belt loop. Finally, draw a curl of smoke around the cigar and add a few bits of flame around the main body of the blaze.

COLOR TIPS

Enhance the feeling of light and heat rising up with little indications of yellow and red around the bottom surfaces, like under his chin and nose.

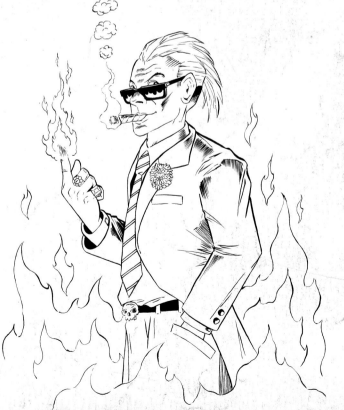

5 Erase the unnecessary lines, check for mistakes and darken the shadows. Because of the flames, the light source is coming from below, so the shadows are on top of Mr. Scorch's shoulders and the upper bridge of his nose. When you ink over your drawing, make the lines around his shoulders thicker than those closer to the light source (the flame).

To add to his creepy factor, give him some rings, a carnation, and a little skull belt buckle. Draw tiny licks of fire for the reflection in his sunglasses.

Female Villains

They're just as bad as any male super-villain and they look better in a skintight costume, but a super-villainess doesn't need to rely on her beauty to get what she wants. She's ruthless and powerful and that power (or firepower) should be drawn as dynamically as any other villain's. Foreshortening and motion lines combine to portray Ms. Massacre mid-attack.

1 Since this pose has much of her body foreshortened, you'll see very little of her lower torso or legs.

MS. MASSACRE

Number One on Interpol's Most Wanted list, Ms. Massacre is the world's foremost hired killer. Her unerring accuracy combined with her time-stop ability makes her a formidable foe.

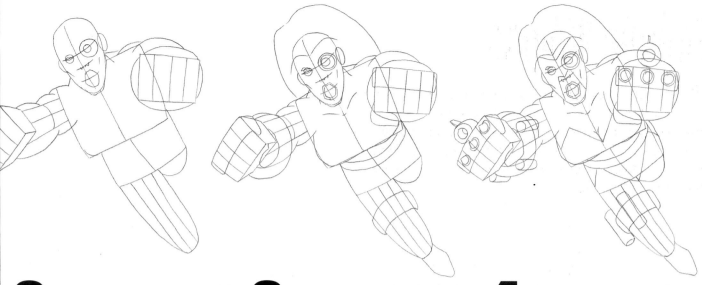

2 Add the musculature. Her left leg is hidden by her torso, so you'll only see a small portion of her left thigh.

Refine the contours of her jawline, then sketch in some of her facial detail, including her left eyepiece and ear cups. Indicate her fingers.

3 Draw the contours of her hair and hairline, then give her eyebrows and lips. Indicate her thumbs and add her right foot. Begin the basic costume elements, such as the steel *cestus* on her fists (ancient Greek weapons, like brass knuckles), her belt line and the strap on her right thigh.

4 Indicate the steel points and gun barrels on her cestus. Add ammunition cylinders to her wristbands and a pair of thermite grenades to her thigh strap. Sketch in the details of her costume, such as her 3/4 mask and tights.

5 Erase the guidelines, fix any drawing mistakes and strengthen the remaining art. Pencil in the seams and circuitry on the grenades and ammo cylinders. Add the cross hairs to her left eye piece and add a little trim to her costume, particularly around her face mask and chest logo. Add flashes from the gun barrels and a series of motion lines behind her.

Use a ruler and a pen to ink the motion lines. Motion lines look better when they're absolutely straight.

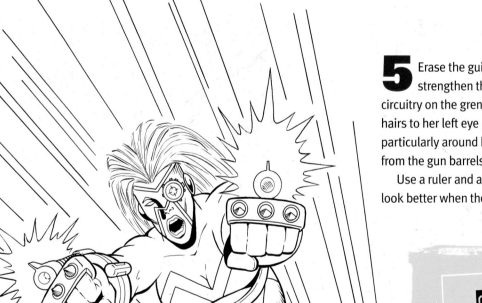

COLOR TIPS

Ms. Massacre's brightly colored hair makes her stand out from the pack. Use the fine-tip end of a red marker for the flash from the gun barrels. Try blue highlights for the background motion lines for contrast.

Robots

Details are the key to any good drawing. With heroic or villainous machinery, the little things, such as seams, circuits and rectangular pupils, add to the inhuman qualities of the character.

COLOR TIPS

Instead of filling in the face with the brush end of a flesh-colored marker, try using the fine-tip side and drawing a series of hatch lines. This will give the face a not-quite-normal looking flesh tone. You can also brush a color-less blender for mark-ers over the red eyes to give the illusion of a faint glow.

ULTI-MECHA

The Fountainhead Corporation developed Ulti-Mecha as battle robot, but its adaptive positronic brain and ego software created a free-thinking robot—one that, unfortunately, views humanity as its enemy.

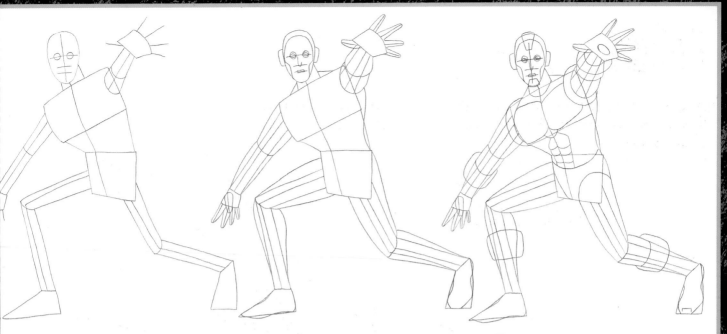

1 Lightly sketch a basic skeletal structure and fill it out with tubing. Draw facial feature guidelines and add eyeballs. Indicate the positions of the fingers and thumbs.

2 Make the contours of the limbs more like tubes of metal than organic arms or legs. Simplify the facial features, too. Draw eyelids, but not eyebrows. Indicate the bridge of the nose, but don't draw nostrils. Add the mouth, but leave out any indication of a lower lip. Outline the face as though it were a mask, then add ear cups. Fill out the fingers and refine the shape of the feet.

3 Add metal plates to top of the head and on the chin. Add rectangular irises. Detail the metal chest and abdominals. Add metal bands to the shoulders, forearms and calves.

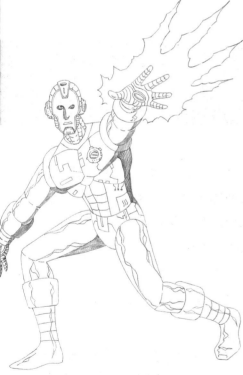

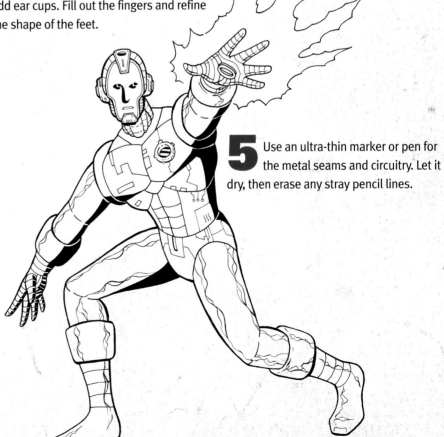

5 Use an ultra-thin marker or pen for the metal seams and circuitry. Let it dry, then erase any stray pencil lines.

4 Erase the guidelines, then sketch in cables for the neck and indicate seams and circuitry throughout the face and body. Darken the shadows and the eyeballs around the irises.

Alien Villains

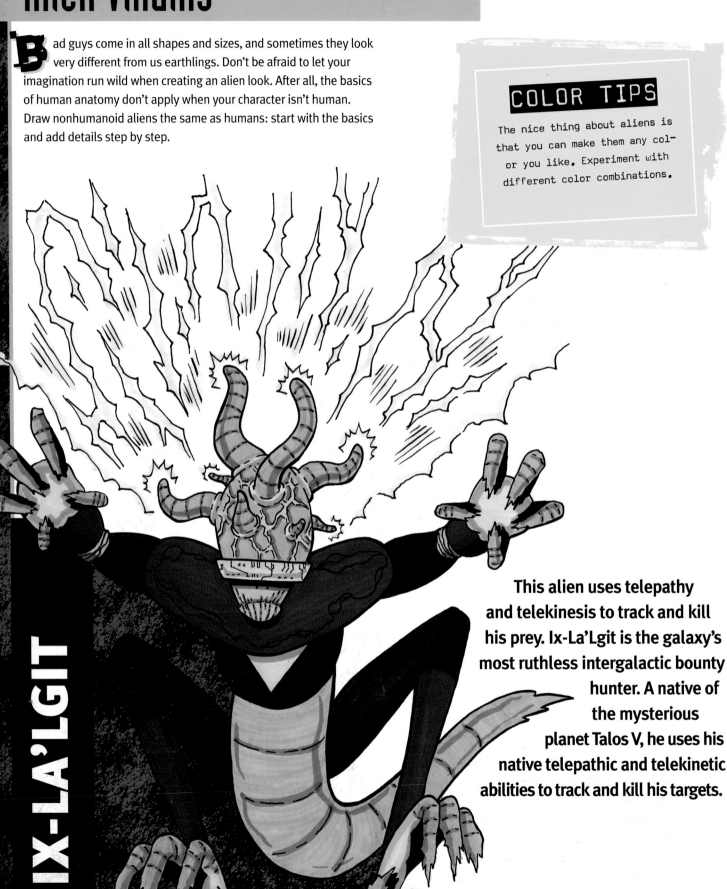

Bad guys come in all shapes and sizes, and sometimes they look very different from us earthlings. Don't be afraid to let your imagination run wild when creating an alien look. After all, the basics of human anatomy don't apply when your character isn't human. Draw nonhumanoid aliens the same as humans: start with the basics and add details step by step.

COLOR TIPS

The nice thing about aliens is that you can make them any color you like. Experiment with different color combinations.

IX-LA'LGIT

This alien uses telepathy and telekinesis to track and kill his prey. Ix-La'Lgit is the galaxy's most ruthless intergalactic bounty hunter. A native of the mysterious planet Talos V, he uses his native telepathic and telekinetic abilities to track and kill his targets.

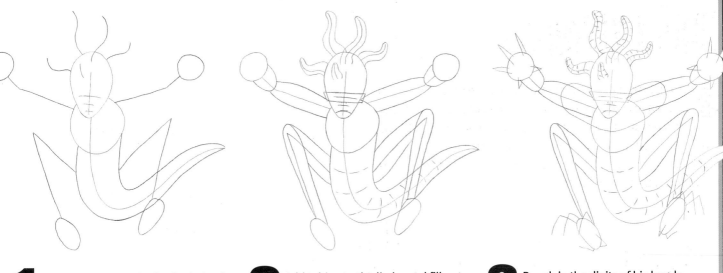

1 Rough out Ix-La'Lgit's basic skeletal structure. Because of his alien physique, the structure will include a larger upper skull with worm-like appendages and a serpent-like torso. Draw his facial feature guidelines farther down on the skull than you would for a humanoid creature.

2 Add tubing to the limbs and fill out the "headworms." Sketch in the eye shield and the slits of his nostrils and mouth. Indicate the creases on his torso and tail.

3 Rough in the digits of his hands and feet. Lightly sketch in his shoulder armor and indicate the creases on the "headworms."

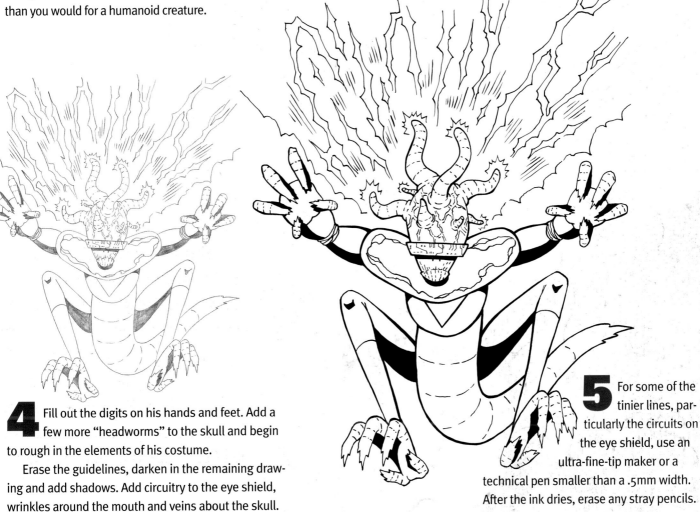

4 Fill out the digits on his hands and feet. Add a few more "headworms" to the skull and begin to rough in the elements of his costume.

Erase the guidelines, darken in the remaining drawing and add shadows. Add circuitry to the eye shield, wrinkles around the mouth and veins about the skull. Draw crease marks on the fingers and toes. Finally, add Ix-La'Lgit's telekinetic effect.

5 For some of the tinier lines, particularly the circuits on the eye shield, use an ultra-fine-tip maker or a technical pen smaller than a .5mm width. After the ink dries, erase any stray pencils.

Super Villains

A super villain this physically powerful has to look the part, so he needs to be drawn with extra-large muscles, hands and feet.

1 Give the Red Death Masque a larger than normal chest and trunk. His hands and feet are also over-sized. Because of our slight worm's-eye view (lower vantage point), the flames coming from his head will hide his neck. Looking up at him makes him seem even larger.

Not every villain is born; some are made in a laboratory. This artificial life form was created by an evil genius to be an unstoppable engine of destruction.

RED DEATH MASQUE

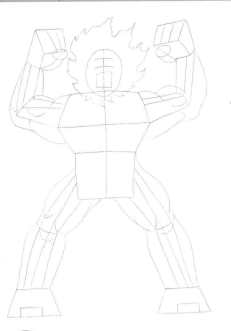

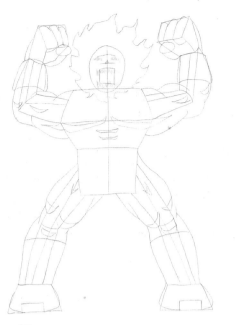

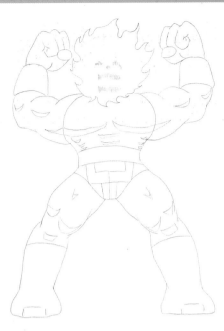

2 Flesh out his body with massive muscles. Don't be shy about it. For a brute like this, there's no such thing as too much. Rough in the thumbs and the flames surrounding his head.

3 Round off his knuckles and fingers, and the contours of his feet. Sketch in his wristbands and boots. Because his facial features are obscured by the flames, indicate his eyes, nose and mouth with a series of hatch lines. Add more detail to his muscles.

4 Erase the guidelines and darken the remaining art. Rough in the basic design of his costume.

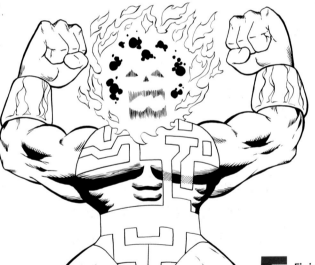

5 Finish detailing the costume and darken the muscles. Add some reflective squiggle lines to the wristbands and boots. Detail his fiery skull with a few smaller licks of flame dancing around it. Add some Kirby dots within the main body of the blaze for the "nuclear fire" feel.

As you go over your drawing with ink, add some feathering (see page 64) in the black areas to add depth. Vary the line weight on the contours of his body, especially around the muscles, so you don't end up with a straight outline.

Fight Scene

Fight scenes may seem complicated, but they're just like all the other drawings you've done. Just break the characters down into their basic shapes and build them up step by step.

The classic battle between brute strength and super science plays out again and again. With the strength to lift one hundred tons, the lizard-skinned mutant Antaeus fills with rage when Professor John Parker a.k.a. the Alloyed Man, clothed in armor and high-tech weaponry, scores a strike against him.

COLOR TIPS

Use red and yellow in Alloyed Man's costume as complements (see page 14) to the green and purple in Antaeus's costume. Use the fine-tip end of a green marker to add hatch marks to Antaeus's muscles for a bit more texture.

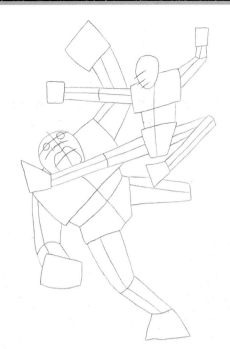

1 After you've decided on an exciting pose, lightly sketch the basic structures of your combatants. Don't worry about overlapping lines. You want them to be making contact with each other. Draw rough facial feature guidelines.

2 Add tubing to the structures and indicate the joints. Rough in Antaeus's eyes, nose and mouth. Leave out the Alloyed Man's facial details since he has a full-face mask. Erase the overlapping lines to better distinguish between the two fighters.

3 Add muscles and fingers. Refine the Alloyed Man's jawline and indicate his faceplate, ear cups and left foot behind Antaeus's foreshortened left knee.

Detail the chest and abdominal muscles. Add the Alloyed Man's shoulder, wrist and shin guards, then the extended shell on his helmet. Detail Antaeus's eyes and eyebrows and add his headfin. Draw thumbs and refine the contour lines of the fists and feet before adding toe boxes.

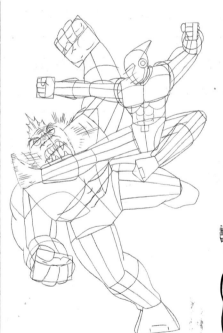

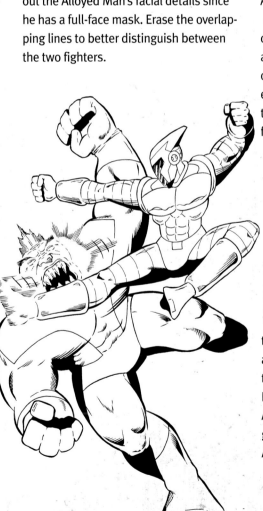

4 Give Antaeus jagged teeth and detail his nose and forehead. Add speed and impact lines to the Alloyed Man's right foot and the left side of Antaeus's face. Add costume details like the muscles of Alloyed Man's chest and abdominals.

5 Erase the guidelines and fix any errors in proportion or pose. Add the armor seams on the Alloyed Man's arms and legs and the back of his head, then refine the design on his faceplate. Darken the muscles and shadows of Antaeus's body for depth. Add thin, squiggly lines for the reflective surface of the Alloyed Man's armor.

Outer Space

So now you've got superheroes and super villains. They're armed with weapons and amazing powers. Now, you just need to give them somewhere to exist. Your characters need settings in which to carry out their battles.

All settings are made up of smaller, basic component parts that are pieced together to create a whole environment. Deep space components consist primarily of planets, stars, spaceships and, of course, your superheroes.

Overlap a larger planet with a nearby moon for depth.

Each planet should have its own look.

Saturn-like rings set this planet apart.

This plane be Earth-l design, wi ible contin

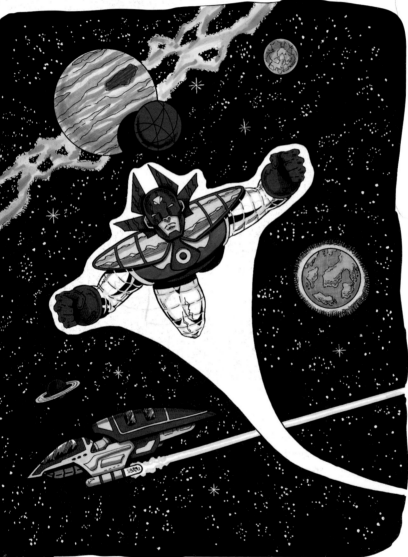

1 Block in the basic elements. Put your hero in the foreground, near the center. An extreme foreshortened view of him flying towards us adds drama. Place a few planets of varying sizes in the background. Break your spaceship into basic shapes before drawing its details.

When danger threatens the universe, the Galactic Guard soars into action. Here, a member of the Guard patrols the outer fringes of the Milky Way.

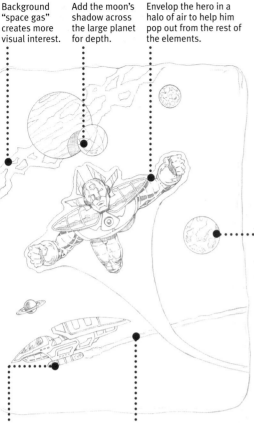

Background "space gas" creates more visual interest.

Add the moon's shadow across the large planet for depth.

Envelop the hero in a halo of air to help him pop out from the rest of the elements.

Small, broken lines give texture to the continents.

Seams and joints give your ship a more mechanical look.

An energy trail shows the ship's movement.

2 After fleshing out the drawing with a few more details, erase your guidelines and darken the remaining drawing. Since the hero is encased in armor, remember to add those little squiggly lines to indicate metallic reflection.

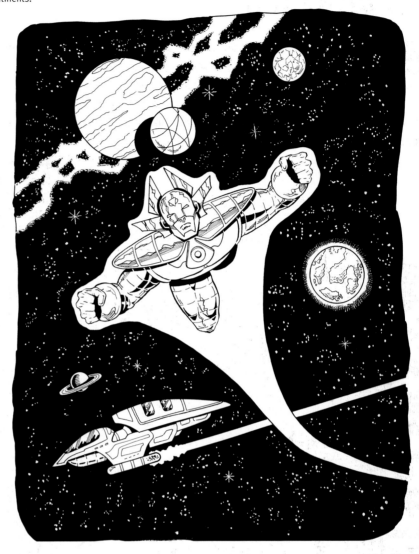

3 Use a thinner line to detail the planets and the ship, and draw reflective squiggles on the hero's armor. Use a thin line to crosshatch the halo of atmosphere around the Earth-like planet.

Use a no. o watercolor brush (that's a really small brush) with some water-thinned white paint to add the background stars. Don't put any stars in the moon-shadow on the large Jupiter-like planet. Keep the stars round, vary their size and make their groupings look random. Add a few twinkling stars for variety. White paint will soften the edges of the space gas so it looks more like smoke.

ANOTHER WAY TO MAKE STARS

If you don't have any paint brushes on hand, try using a toothbrush! Just dip the bristles of the toothbrush into a small amount of water-thinned white paint, then flick the paint off the bristles and onto your art. Be very careful with this method though! It's difficult to control where the paint goes so you may end up with stars in places they shouldn't be.

Natural Surroundings

For this peaceful environment your basic components are water, trees, grass and the mountains.

The frame overlaps the tree and pond to establish the foreground.

Mountain range with overlapping, irregular, triangle-like shapes.

Ground line

Horizon line

THE VALE OF CONTEMPLATION

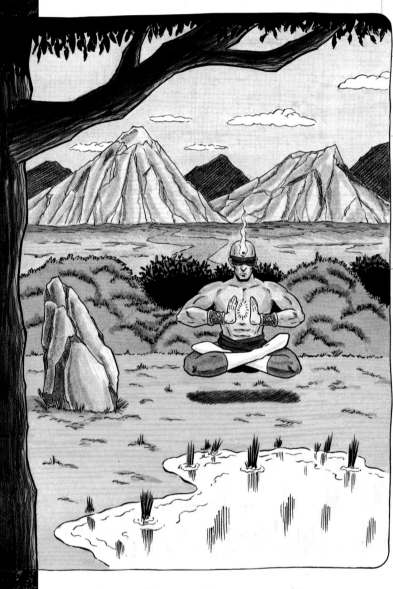

1 Most settings contain three levels: the foreground, the middle ground and the background. Here, the frame of the picture overlaps the tree and the pond to create the foreground. Create a ground line and an unobstructed view of the hero in meditation to establish the middle ground. Add a rock to the left for weight and balance. Block in the background with the horizon line and a long shot of a mountain range.

Even the world's greatest martial artist needs time to rest and meditate. Here, the Master of Five Styles replenishes his superhuman strength and speed by absorbing cosmic energy through the gem on his forehead.

Thin, jagged lines for the rock and background mountains.

Drop shadow.

Shrubbery.

Thin, squiggly lines close together for tree bark.

Shadowed leaves on the tree and the shrubbery to separate the fore and middle grounds from the background.

Darker background shrubs for another level of depth.

Trail leading off into the horizon line also adds depth.

Periodic clumps of leaves for shrubs.

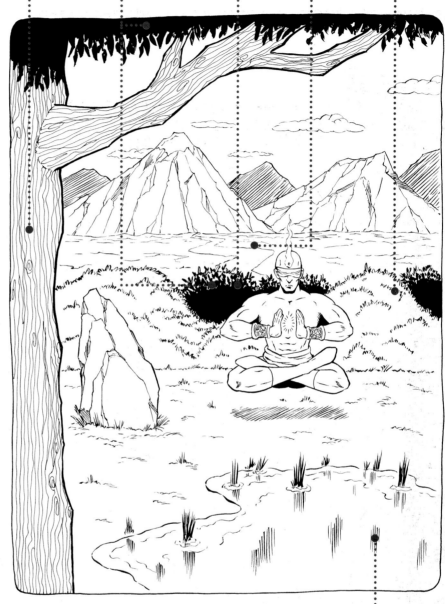

Vertical lines for the reflection of the water's surface.

2 Fill out the hero's musculature and add a drop shadow to indicate that he's floating above the ground. Draw some bushes at the middle ground line to separate it more from the background. Place a few extra mountains behind the original two for more depth.

COLOR TIPS

A brighter, primary palette (reds, greens and blues) allows the middle ground to pop out from the foreground tree and the background mountains colored in grays and browns. Apart from the rock, don't use gray in the middle ground at all. That will make it appear enclosed by the background and foreground.

3 Add a blindfold, a forehead gem and wristbands to the hero's costume. Add a few more details to the scenery, such as grass and bark on the tree, then erase your guidelines and darken the remaining drawing.

Generally speaking, flat black areas pop out more than white areas, so ink foreground objects a little thicker than background objects. In this case, for example, make the tree's outlines thicker than the mountains' to enhance the illusion that the tree is closer.

Urban Scenes

Aside from Aquaman and the SubMariner, most heroes operate in the city (not to mention dry land). Because of this, an urban locale is probably the most commonly used background. Look in the newspaper and in popular magazines, and at your local library for reference photos and drawings of various types of buildings to practice with.

The basic shapes of most modern business buildings are squares and rectangles.

Most business buildings have square or rectangular-shaped windows.

1 For variety's sake, make the foreground building an older, brick-and-mortar type, and the background buildings glass-and-steel type skyscrapers.

SENTINEL OF THE CITY

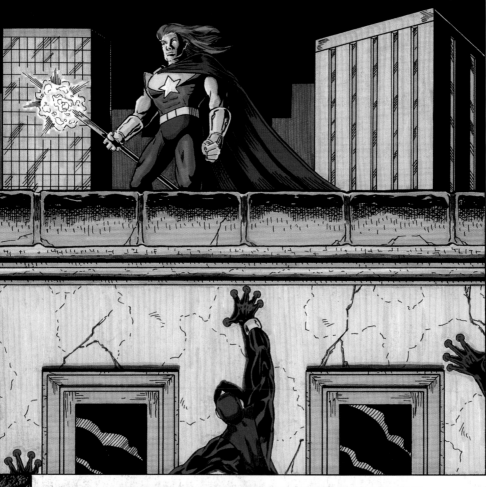

When night falls, evil crawls out of its hiding place to cause pain and destruction. Only the light of the hero Morning Star stands between the sleeping city and the powers of darkness.

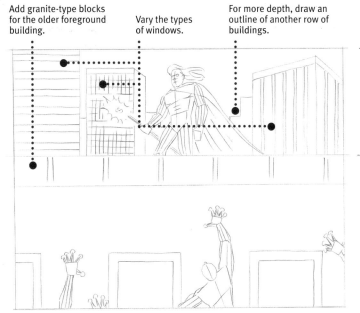

Add granite-type blocks for the older foreground building.

Vary the types of windows.

For more depth, draw an outline of another row of buildings.

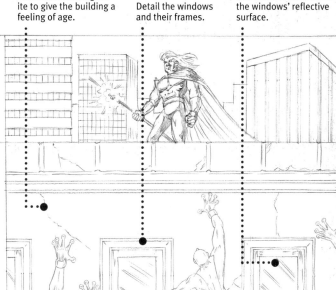

Add cracks to the granite to give the building a feeling of age.

Detail the windows and their frames.

Use hatch lines to show the windows' reflective surface.

2 Fill out the hero's body with musculature, then rough in the windows of the background buildings. Add mysterious climbers to the front of the foreground building.

3 After adding more detail to your hero's face and costume, erase the guidelines and indicate the shadows.

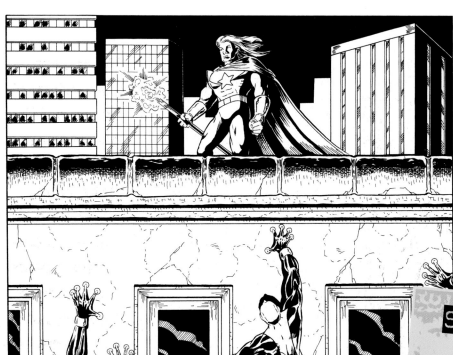

4 A night scene in comics usually means simply inking in the sky, but the feeling of darkness can be enhanced even more by increasing the amount of flat blacks (see sidebar) used. In this case, ink in the sides of the background buildings and windows of the foreground buildings completely. Add dark shadows to the tops of the foreground roof's granite blocks to show the effects of the lights of the street below.

SHADING ADDS DEPTH TO A DRAWING

1 Ink without shading looks plain and two-dimensional.

2 Crosshatched lines add dimension and show that a moderately bright source of light is coming from the left.

3 Flat (or solid) black gives the best depth. This shows a strong single source of light coming from the left side.

3 SCRIPTS, STORIES, PANELS and PAGES

kay, so now you've got the basic elements: a rugged, dashing super-hero; a beautiful and dynamic superheroine; a group of dastardly henchmen; and an incredibly vile and powerful villain. Naturally, you'll want to put them all into a comic book. Assuming you're working alone, rather than being part of a creative team that includes a writer, the next step is to plot and write the script.

Pages From the Comic 7-SEI

7-SEI is about a group of earthlings imprisoned on the planet V'Nar. These pages show the V'Narian Prime Minister traveling to the prison site.

I was fortunate to be able to collaborate with writers Debra Robins and Brian Kaya to create the essential characters and the overall plot. Debra crafted a full script (complete with panel descriptions and dialogue) based on the plot outline. I penciled and inked the pages according to the action indicated in the script.

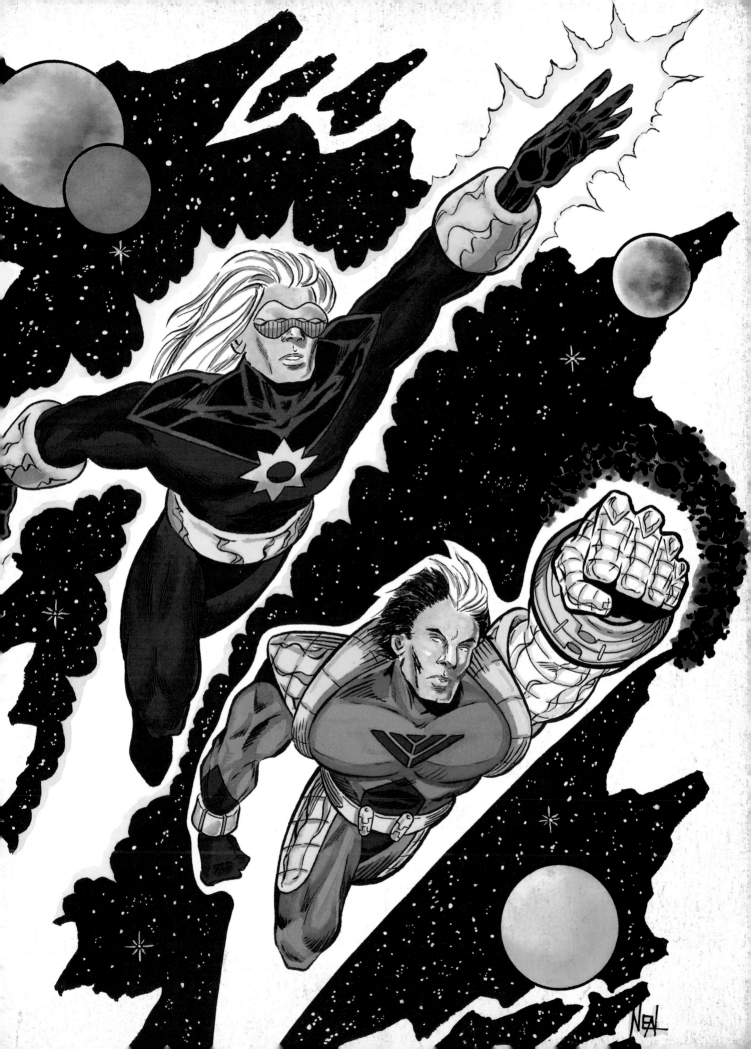

THE PLOT AND THE SCRIPT

The first thing you need is a good plot. The plot should summarize what happens in the story. It should introduce the characters (your heroes, villains and side characters), create a conflict (the reason for the fight and the actual fight), reach a climax (well, somebody has to win the fight), and end with a resolution (what happens after the fight).

The purpose of the script is to flesh out the plot into a complete story that the artist—in this case you—can illustrate. There are two ways of doing this:

1 Write out a brief summary or outline of all the action that's happening on each page of your comic. Then draw the pages, leaving room for the eventual dialogue and captions. Then finally write the dialogue to fit the pictures.

2 Write a full script, where all the action, dialogue, number of panels and panel descriptions are written out in detail before beginning any artwork.

The One-Person Show
If you're working alone, you'll need to juggle the duties of writer, penciler, inker, letterer and colorist.

SAMPLE PLOT OUTLINE

Remember, the plot outline just gives a general idea of what's going on in each panel. The artist translates each point of the outline into a panel illustration.

PAGE ONE

1 Sunburst suddenly flies off, leaving an angry Death Warrant behind, floating above the treetops.

2 Sunburst contentedly soars across the blue skies, not a care in the world. Death Warrant is not happy and chases after him, coming up from behind like a guided missile.

3 Realizing that he's too slow to catch up, DW gets angry and fires an energy bolt at Sunburst.

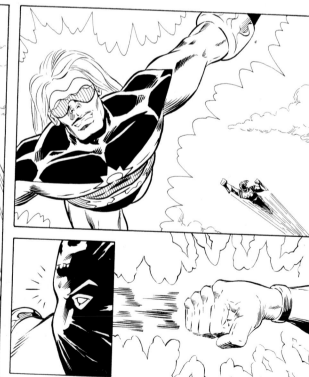

SCRIPT BASICS

"DEAR SIR, *PLEASE* SEND ME A SCRIPT..."

TAP! TAP! TAP! TAP! TAP!

Here are a couple of things to remember (written in the full script format).

Ask for a Sample Script
It's always helpful to get a look at the format and style the pros use in writing their stories.

THE SCRIPT

PAGE ONE (FOUR PANELS)

PANEL 1: Establishing shot of the writer, Neal, at his computer. He's writing a panel description, which describes the general setting and action in the panel.

CAPTION: MEANWHILE . . .

NEAL: RULE ONE: DON'T PUT TOO MUCH DIALOGUE INTO A SINGLE PANEL.

NEAL (thought): THAT INCLUDES THOUGHT BALLOONS, TOO.

PANEL 2: A medium, bird's-eye view of Neal typing and muttering to himself.

NEAL: GENERALLY, NO MORE THAN TWENTY-FIVE WORDS PER WORD BALLOON AND FIFTY WORDS PER PANEL; FEWER, IF THE PANEL IS A SMALL ONE.

PANEL 3: A close-up of the computer screen. If your character is off-panel, then you should indicate that with the abbreviation "OP."

NEAL (OP): RULE TWO: PACE THE ACTION ACCORDING TO HOW MUCH SPACE YOU HAVE. YOU DON'T WANT TO BE FORCED TO PUT TWENTY PANELS ONTO ONE PAGE.

PANEL 4: An extreme close-up of Neal's mouth.

NEAL: MANY COMIC BOOK COMPANIES WILL SEND YOU A SAMPLE SCRIPT IF YOU WRITE OR E-MAIL THEM REQUESTING IT (REMEMBER TO SAY PLEASE).

NEAL (whisper): YEAH, THAT'LL DO IT.

LAYING OUT A COMIC PAGE

Comics are sequential art. That is, a story is told through a sequence of art panels set up in a specific order. It means that you need to make sure your panels are set up on the page in an order that the reader can easily follow. In the Western world, we're trained to read from left to right and from top to bottom, so set up your panels that way.

Paneling Basics
The basic comic page set up is paneled with an orderly, if somewhat uneventful, design of squares and rectangles.

PANELS The frame in which your art-work appears.

GUTTERS The space in-between that separates panels.

Remember the Eye's Path as You Create Panels
These arrows show the path the eye would normally take. It's the same path the eye follows when reading a page of text.

Dynamic Paneling
The basic comic page can be redesigned to create a greater sense of movement and visual interest. Panels don't have to be just standard squares and rectangles. They can be any shape or size and can contribute to making your comic page even more interesting to look at.

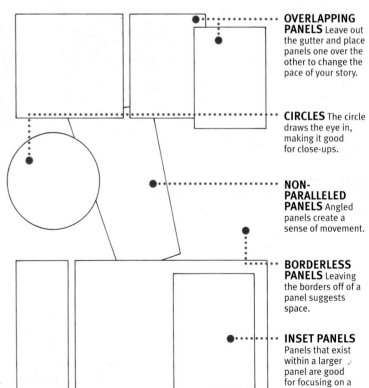

OVERLAPPING PANELS Leave out the gutter and place panels one over the other to change the pace of your story.

CIRCLES The circle draws the eye in, making it good for close-ups.

NON-PARALLELED PANELS Angled panels create a sense of movement.

BORDERLESS PANELS Leaving the borders off of a panel suggests space.

INSET PANELS Panels that exist within a larger panel are good for focusing on a specific action or person within a larger picture.

POINT OF VIEW

Just like the director of a movie, the artist controls the point of view in a scene. Draw panels from one of three different points of view: eye-level, bird's-eye or worm's-eye.

Eye-Level View
This is basically a straight ahead shot. The reader's view is on the same level as the characters in the scene.

Bird's-Eye View
Sometimes called a high-angle shot, this view is from above the level of the characters in the panel.

Worm's-Eye View
Sometimes referred to as a low-angle shot, this view is from below the level of the characters in the scene.

SHOT SELECTION

Despite the name, shot selection is not just something done on a rifle range or a basketball court; it's also how you decide to set up your panel of art. Selecting a shot is a lot like being the director of a movie; you're controlling the look and the pace of the story. Despite some inherent differences between motion pictures and comics (after all, one moves and the other doesn't), it's still useful to study books on movie storyboarding. The following shots are based on ones commonly used in film.

Establishing Shot or Long Shot

Usually a long or panoramic view that shows the general environment. This shot establishes the locale and, very often, the time the events are taking place.

Medium Close-Up or Waist Shot

A tighter shot on the characters, usually showing them from about the waist up.

Medium Shot or Full Shot

Also called Action Depth Shot, this is any view that shows the character's entire body. This shot is good for showing action and giving a full view of the character.

Close-Up

Tight shot, usually the full face of a character or object; good for showing facial reactions.

Extreme Close-Up

A really tight shot on a section of a character or object; generally used for dramatic emphasis.

LETTERING AND WORD BALLOONS

Whether you do it by hand or on the computer, your comic book lettering must be neat, clean, legible and free from spelling or punctuation errors. Bad lettering will destroy a page of artwork faster than kryptonite.

Traditionally, hand lettering is done directly onto the penciled art page, before the inking stage. Professional comic book lettering is usually done at a scale of ⅛" (3mm) for the letters with a ¹⁄₁₆" (2mm) space between the lines. You can rule the guidelines with a ruler or use a little plastic template called an Ames guide set to 3 ¼" (8cm) that's available at most art stores. Almost all comic book lettering is upper case only, mostly for legibility's sake. After all, when it's printed it's reduced down to about ¹⁄₁₆" (2mm).

Most hand letterers use either a dip pen with a lettering nib, like a Speedball A-5 or B-5½ nib, or a cartridge type pen, like the Rotring lettering pen. However, like everything else in art, anything goes as long as it works.

CAPITAL TRADITIONS

Traditionally, lettering is done in all capital letters, but styles are changing. Different styles of lettering are used now to create other effects. Small letters suggest mumbling and creative fonts are being used to show alien languages.

Lettering Helps Tell Your Story

CAPTION BOXES are usually used for narratives or off-panel dialogue. Bold lettering shows emphasis or yelling.

WHISPERS are indicated by a dotted-line balloon and slightly smaller lettering.

STANDARD WORD BALLOONS are usually oval-shaped.

The **TAIL** of the word balloon indicates who is speaking.

CLOUD-LIKE BALLOONS show thoughts.

JAGGED-LINE BALLOONS AND BOLD LETTERS indicate yelling. Add exclamation points if your character is really loud.

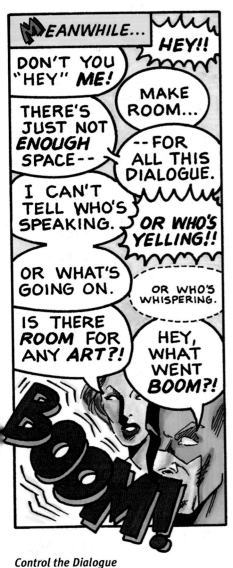

Control the Dialogue
Always make sure you've left enough space for both the lettering and the artwork.

Display Lettering
Whether it's the "POW!" of a punch or the "SSKRAAAACKK!!!" of a force bolt, it all falls under the category of display lettering.

Display lettering refers to the sound effects (sometimes abbreviated as SFX), titles and logos used in a comic. There are no real rules about this type of lettering and many styles of display lettering are an art form unto themselves.

GETTING INTO THE BUSINESS

Doing comics for fun is easy. Doing it for money can be as hard as arm-wrestling the Hulk. The first thing to do is to perfect your artist skills and that takes a lot of study and practice. Take as many art courses as possible, particularly life drawing, perspective and design. Visit museums and art galleries. Learn about art history and be open to all forms of visual art and communication.

The second thing is to learn as much as you can about how the comic industry works. Big comic companies tend to produce books via assembly line: One person writes the script, another pencils it, someone else letters it, another inks it, one more person colors it and in between it all an editor checks and rechecks before shipping it off to the printer. Independent creators do almost all that themselves. It's a lot of work and you still have to meet a deadline.

And lastly, to be professional is to be dependable. Finish what you start and never stop learning.

INFORMATION SOURCES

There are loads of books and Web sites out there about the business of art and how to prepare for it. These are just a few of the sites that offer good information on how to break into the business.

CREATING COMICS WWW.MEMBERS.SHAW.CA/CREATINGCOMICS
Contains numerous articles about the industry written by professionals in the field as well as lots of good tips on penciling, inking, coloring and lettering.

DARK HORSE COMICS WWW.DARKHORSE.COM/
Along with submission guidelines, they also provide a downloadable copy of a sample script and hints to getting someone to review your portfolio.

DC COMICS AND MARVEL COMICS
WWW.DCCOMICS.COM/ AND WWW.MARVELCOMICS.COM/
Both the Big Two comic companies provide submission guidelines on their sites.

DIAMOND COMIC DISTRIBUTORS, INC.
WWW.VENDOR.DIAMONDCOMICS.COM
Along with lots of information about how to market and distribute a book, Diamond's site has a listing of professional letterers, colorists and printers you can work with.

DIGITAL WEBBING WWW.DIGITALWEBBING.COM
There is a job section on the site for writers, pencilers, inkers, letterers and colorists.

SAN DIEGO COMIC-CON INTERNATIONAL WWW.COMIC-CON.ORG/
Conventions are great places to show your art and get professional feedback. The annual San Diego Comic-Con is the biggest and all the major comic companies are there. Their site also has information on the Alternative Press Expo (APE) a convention for independent comic creators and publishers, and San Francisco's WonderCon.

STICKMAN GRAPHICS WWW.STICKMANGRAPHICS.COM/RESOURCE.HTM
While this site is primarily concerned with the printing end of things, it also has helpful articles about how to effectively produce comics.

Perfect Your Artist Skills
Never stop learning your craft.

Study and Appreciate All Forms of Art
This will give you a broader range of experience and will improve your work.

Go to Conventions and Meet the Pros
Ask professionals to critique your work and listen to their advice.

Always be Dependable
If someone is willing to pay for your art, deliver that art on time.

INDEX

CHECK OUT THESE OTHER GREAT *IMPACT* BOOKS!

These books and other IMPACT titles are available at your favorite fine art retailer, bookstore or online supplier. Or visit our website at www.impact-books.com.

Draw Comics With Dick Giordano

Whether you're a beginner or an accomplished artist, you'll sharpen your drawing skills with comic industry legend Dick Giordano. Packed with lessons, dynamic illustrations, demonstrations, drawing secrets and tips for perspective, inking, paneling and storyboarding, you'll find inspiration and instruction inside this quintessential guide to comic art.
ISBN 1-58180-627-2, Paperback, 128 pages, #33200

Comics Crash Course

With the 20+ step-by-step demonstrations in this book, you can create amazing comic book art like an expert! Vincent Giarrano shows you how to draw eye-popping characters, poses, expressions, weapons and devices, and full comic book pages. Inside this start-to-finish guide, you'll also find valuable advice on how to publish your own comic book and make it as a professional comic artist.
ISBN 1-58180-533-0, Paperback, 128 pages, #32887

Superhero Madness

Draw superheroes and other characters with this illustrated guide. David Okum teaches you to draw a variety of characters, starting with the basics of heads and faces and taking you up to figures, proportions and dynamic poses. You'll also learn to draw settings and vehicles, including spaceships, gadgets, armor and more. Whether you want to draw your characters in cool poses or explore visual storytelling, you'll find it right here!
US ISBN: 1-58180-559-4; UK ISBN: 0-7153-2052-1, paperback, 128 pages, #33015

Manga Secrets

This book features over 50 quick lessons with step-by-step instructions for drawing people, creatures, places and backgrounds. Lea Hernandez is one of Manga's most popular artists, and this book is filled with hundreds of her illustrations that will inspire you to draw your own comics. Perfect for beginning and advanced artists.
ISBN 1-58180-572-1, paperback, 112 pages, #33029